A MAP OF THE EAST

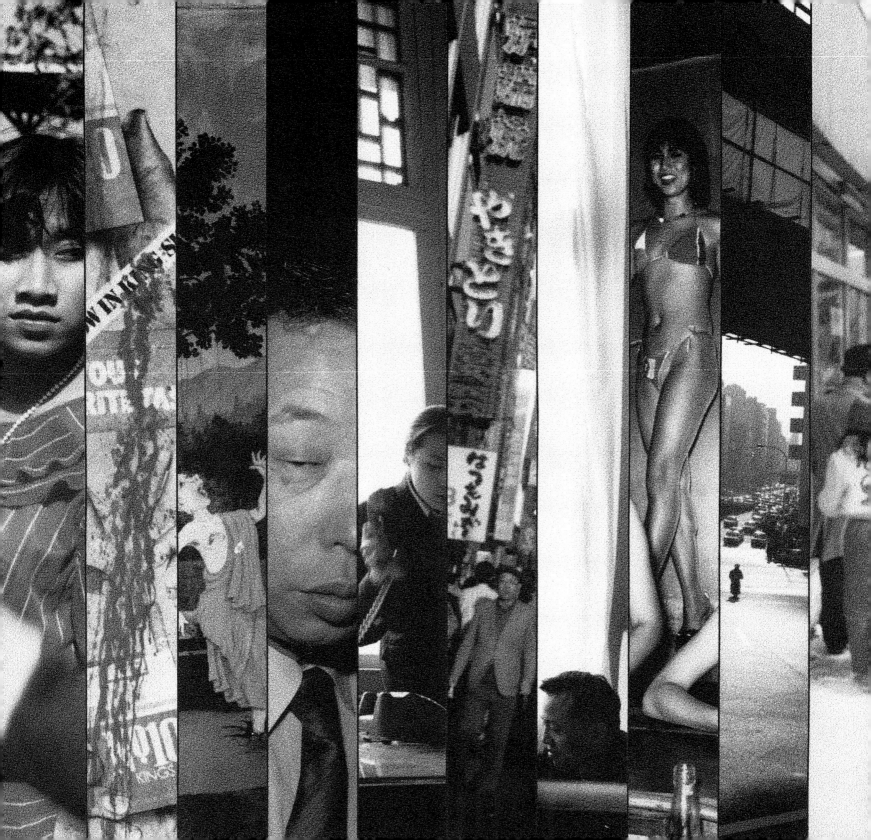

A MAP OF THE EAST

BY **LEO RUBINFIEN** WITH AN AFTERWORD BY DONALD RICHIE

DAVID R. GODINE · PUBLISHER · BOSTON, MASSACHUSETTS

An Imago Mundi Book first Published in 1992 by David R. Godine, Publisher, Inc.

Horticultural Hall · 300 Massachusetts Avenue · Boston, Massachusetts, U.S.A. 02115

The publication of this book was supported in part by grants from the John Simon Guggenheim Memorial Foundation and from Mr. Pepe Karmel.

ISBN: 0-87923-942-5 *Hardcover* 0-87923-943-3 *Softcover*

Library of Congress Catalogue Card Number: 92-70770

First edition

Printed in Japan

FOR SHULAMITH AND DAVID RUBINFIEN AND, OF COURSE, FOR CONSTANCE

INTRODUCTION

by Leo Rubinfien

I GAVE THIS BOOK ITS TITLE with a certain amount of deliberate irony in mind. No collection of photographs, except perhaps if made from space so as to exactly mark the craters of the moon or the recession of the Aral Sea, can ever be anything as measured, as verifiable, as scientific as a map. Only consider for a moment all that one could photograph, if one wanted to: there is the bill-strewn surface of the desk where I write, there is the coffee-stained rim of the cup on the desk, there is the cat hunched in the corner, and, if one had a movie camera, there would also be the specific motion of the cat's minklike tail, languidly slapping the floor. There is the glare of the sun piercing the black snarl of branches outside the house, there are the biceps of the workman digging there, and beyond the farthest trees there is the white cloud touched with pink, with a shape for which no words exist. The possibilities are infinite, and if you chose any one of them, the points-of-view from which it might be seen – intimate, remote, angelically soaring, your face beneath the boot, and so on – would be infinite as well.

This being so, there is something absurd in projecting to map the East in a hundred and seven photographs. The East is not much less than half the world, an infinity of an infinity of objects and vantages, every single one complex with meanings. Beside that plenitude even the most prolific collection of pictures could only seem small and arbitrarily selective, and probably idiosyncratic, probably even perverse. Why not then lighten the odds a little and confine oneself to a modest patch of ground: to the faces, say, of people waiting for the bus at Upper Sendai Hill in Tokyo, where one might even hope to get an extra charge of inspiration from the memory of waiting at that same stop, by the same mossy rock wall, each day after school when one was ten?

Somewhere near what I am talking about lie the old questions of whether it is the job of photography to describe the world or to do something more than that, and whether it *can* do anything more than describe, and whether it can even describe *at all* with any accuracy. If you literally set out to show what the East looks like you will be obliged to do every neon sign, every T-shirt, every pot belly, beard, lip-sticked mouth, kitchen, ship, wharf, bend in the road, palm and pine. You will commit yourself to an impossibility, and probably, in fact, to a labor not worth doing in the first place. It is for this reason that you cannot begin from trying to describe, to merely describe, but must attempt to evoke, always evoke.

And here one hopes to make a virtue of one's idiosyncrasy, of the stubbornness with which the heart's eye chooses, over and over again, *that kind* of lipsticked mouth, *that kind* of sideways glance, *that kind* of light on the palm tree's crown. One hopes that the pattern of one's choosings will add up to a style of seeing. And then one hopes further that this style of seeing will have enough lastingness and depth to amount to an understanding of what one has seen, and even, if one is very ambitious, to an understanding of seeing itself.

I cannot say that I chose to go to Asia to photograph. I did not pick it out from the supermarket of material saying "The increasing importance of Japan to American society over the last decade ...," or "The formal possibilities for making photographs in the back streets of Kowloon...," or even "The disappearance of the ancient dance from the villages of Java is a sorry loss" (although I think the last is so). I chose to go *back* to Asia, and this because I felt compelled to go back, having spent some years in Japan as a child. I should record that I did not spend most of my childhood there, nor my earliest childhood, nor necessarily what a psychologist might think the critical years. But in retrospect the years I spent in Tokyo came to seem signally important to me, even defining of me, and perhaps the best reason why I went back was to find out why this was.

It is a given that I was and am still, when I am there, an alien in the East: that the East is not my world but that of people different from me, that the view expressed in this book is a foreigner's view and that differentness is the core of it, that the things important to me there are things important to a foreigner. Here are some of the important things: the miniature tissue net – paper stretched on a wire frame – which you bought at temple festivals to try, squatting beside a low flat pan, to get a goldfish out and into a plastic bag before the water melted the tissue away; meals of fish and seaweed and rice and pickles intricately composed in fragile wooden boxes and pushed up to you with the cold night air through your express train's window as you stopped for less than a minute en route from the North to the South, or the South to the West; the boxes in which *Peace* and *Hope* cigarettes (their names still now recalling to the alert ear the catastrophe of the Second World War) came, smaller and more delicate than those in America; the three-wheeled trucks, once ubiquitous in Japan and now extinct (and here it is nearly impossible to

articulate what they stood for – were they more toylike than American trucks? Even to frame the question thus seems to abuse the fact, the trucks themselves – and yet one is unshakably convinced they stood for something); the inadvertent poetry of signs, of misused English: the "New Topsy Salon," or the legend on a T-shirt, "We Are a Beautiful People of an Unknown Culture"; the almost imperceptibly lighter gauge of all clothing, everyone living a quarter-step closer to the open air.

Exactly what these things have in common, the exact essence that they share, is exceptionally hard to hold down with a single name. Talking with friends I trust I have sometimes and very cautiously spoken of the "innocence" of the East, but always felt this to be a bad word. Yet one needs *some* kind of a word for what one recognizes reading in *The Makioka Sisters,* for instance, of the hunt along the dark bunds for the place where there were galaxies of fireflies, and of the girls secreting some away to pulse inside their kimonos' voluminous sleeves – some word for what one sees incontrovertibly there in Kurosawa's *Ikiru,* when the frantic, decrepit Takashi Shimura hugs to his chest the furry mechanical rabbit, precious as life itself, and the schoolgirls offscreen belt out "Happy Birthday to You" tunelessly and in bad English, as blissful as babies.

The same word, were there a good one, would apply to an encyclopedia full of things I cannot imagine our doing or saying or making in the West without first giving a compulsory, self-mocking aside. There is little room in our world for the perfect unselfconsciousness with which, in summer, the girls next door to me in West Ochiai tied thread leashes around the waists of bees and towed them, aloft, up and down the alleys, or with which which a teenaged boy on the ferry dock in Banyuwangi, wanting my address when I had a pen but no paper, prostrated his hand in mine that I might inscribe "...Croton-on-Hudson, New York..." in his brown palm, or of the Bamboo Shoot clan of ten years ago, dancing by the Outer Pilgrims' Road with heartbreaking dedication, to disco songs ("Rah, Rah, Raspu-teen! Lover of the Russian Queen!...") they could not possibly have understood.

For the quality all these things share, an essence for which there is no good word, the pictures in this book might be read as an extended, ungainly name. It seems to me, this essence, stubbornly real enough to be worth trying to name with pictures, though I have worried much about whether it is really real. I cannot

clearly tell how much it is there to be found in Asia and how much it is a tinge I have carried out of childhood and now impose on what I see – all memory of childhood being filled with luminosity whether one is from Dublin or Brooklyn or Santa Barbara. I am not certain, even after years with the pictures, whether they prove the existence of that which they try to name, or if they just assert it. (But then, it is often said, if a picture asserts well enough it proves. And perhaps that is how a picture works).

All that this book would evoke was and is still vanishing. Literary foreigners in Asia – Lafcadio Hearn, Colin McPhee, Donald Richie, Ruth Prawer Jhabvala and the James Ivory of *Shakespeare Wallah,* to name a few – have in fact developed a whole sub-genre of elegy for the disappearing and disappeared. When in 1979 I made my first trip back to Japan since childhood, I was sickened by how much had gone. The next year I made the first of many long trips through Southeast Asia, where in Cirebon, say, you could still ride in a tricycle ricksha lit just by a candle in a glass box that dangled below the axle, and where so riding the only sounds you heard were the hum of the spokes in the wind, the driver's bell, and, from behind the garden walls and hedges the quiet voices of women with their babies in the dark. It was no less fantastic than the music that enchanted the Dutchman Jaap Kunst, who would equate that music, of the Javan gamelan, to nothing but moonlight and flowing water. The Westerner with his eyes open to the East becomes a connoisseur of the gamelan, the candle-box, the shadow puppet, the bamboo bridge and all their relatives, needing them as much, perhaps even more than their Asian inventor, who plows the past under cruelly in his haste to become Western.

And if there is a little too much perfume here – if I seem to be proposing too sentimental a catalogue, on whose cover Tennessee Williams might have stuck the emblem of a Chinese paper lantern – this book will show that the Westerner becomes a connoisseur of much harder stuff as well. Of plastic garbage in the river, of mouths too full of bright gold teeth, of all that slavishly mimics the West, that West of which Hollywood is capital, of rampant kitsch, of the accusatory glance and the impenetrable stare.

Thus, what the Westerner discovers and loves in the East is not just an amalgam of what he needs to see and what is really there, it is also quite degraded and seems more each day, amid the incoming flood of

beliefs, dreams and manufactures from the West, to belong to the irrecoverable past, and to survive only in corrupted forms. Yet in another way it has not passed and is not lost at all. One element of the "innocence" of Asians is the very delight with which they can jettison the past and seem to themselves to pay no price. On inscrutable impulses they will perform the songs of the Beatles with exact intonation, or dress as Wyatt Earp, or make stunningly expensive copies of Fabergé eggs, and the Westerner will marvel at the sweetness and blindness of it. I have arranged the photographs in this book to lead backward in time from that which is more apparently "western" in Asia to that which is less "tainted." This will be helpful to clarity, I hope, but in truth it is a conceit. There is almost nothing in the cities of the East today that is not somewhat tainted, and nothing that is not also utterly Asian.

The question of how much is corrupt and how much not yet corrupted is what drove me through making the pictures in this book. They cannot answer the question of course, and when I look at them now I am struck by their ambivalence, by the mixture of tenderness and irony in their voice. Which is, I hope, exactly right: losing continually, we are also continually enriched by naming that which we have lost, and recognizing that which remains.

I fear this will be a difficult book for two kinds of reader: he who looks for a picture's stylistic response to whatever happened last year in the world of art, and he who seeks a rational story of what's going on in the East today. To the first these pictures may well seem indifferent to the endless arguments about what is and is not art, and if photography is art and when, and what "formalism" is and what "post-modernism" does, et cetera. To the second, these pictures may seem to give inadequate explanation of the grand frames – political structures, economies, cultures, geographies – in which we live. What the pictures are *not* indifferent to, what they are built out of and try to celebrate, is experience itself – human, evanescent, far-flung, felt and understood through some cooperative action of the mind and heart too complex to analyze; it is experience (a particular one, of course) that they refer to and extend from, and which, from time, they hope to protect.

Croton-on-Hudson, 1992

A MAP OF THE EAST

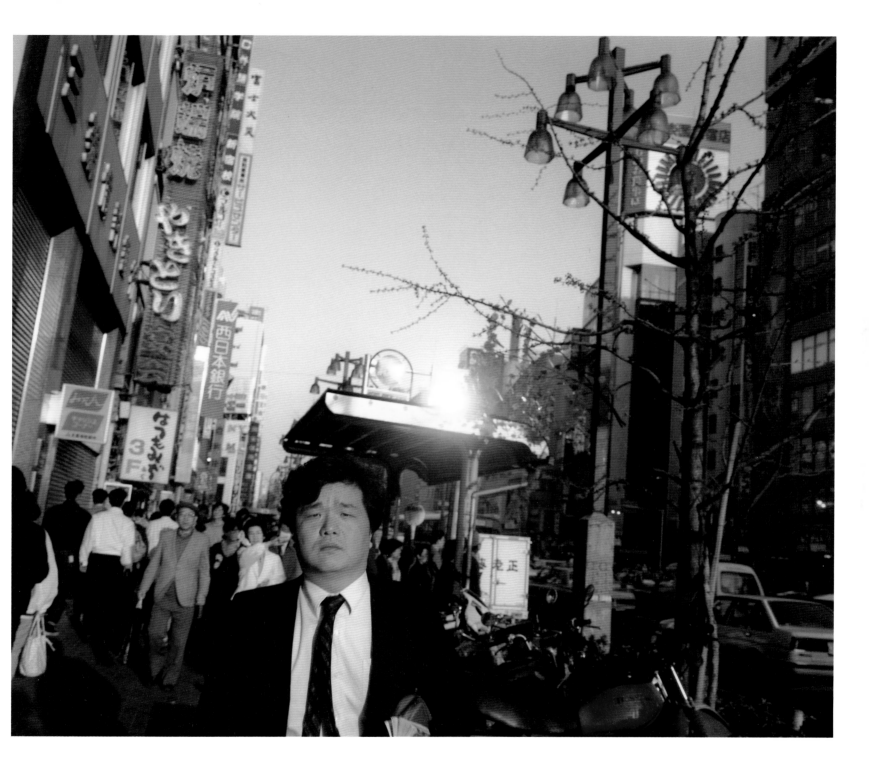

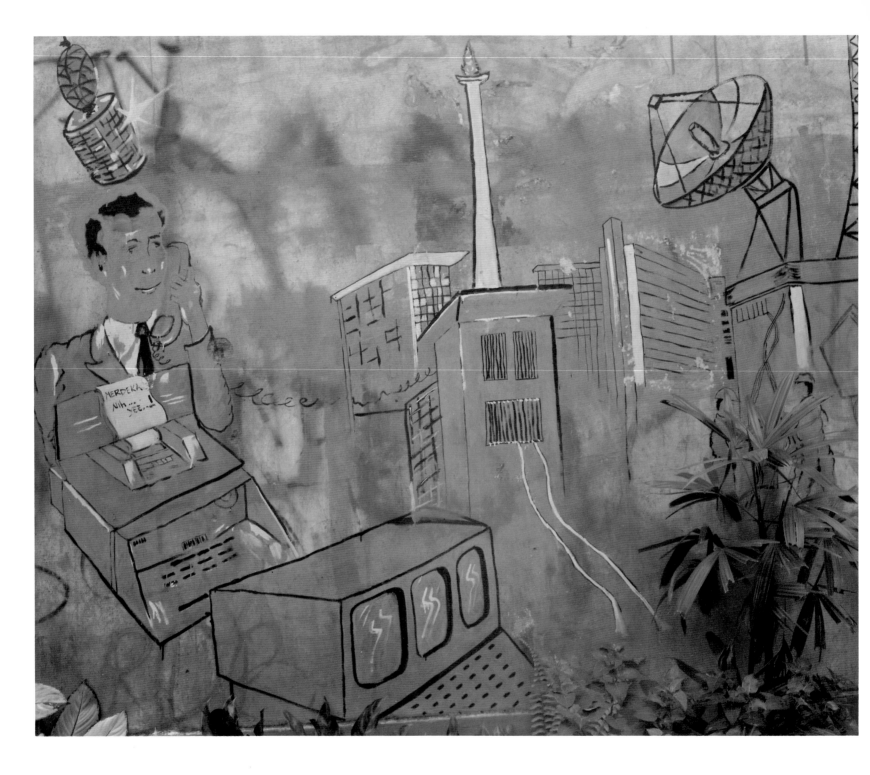

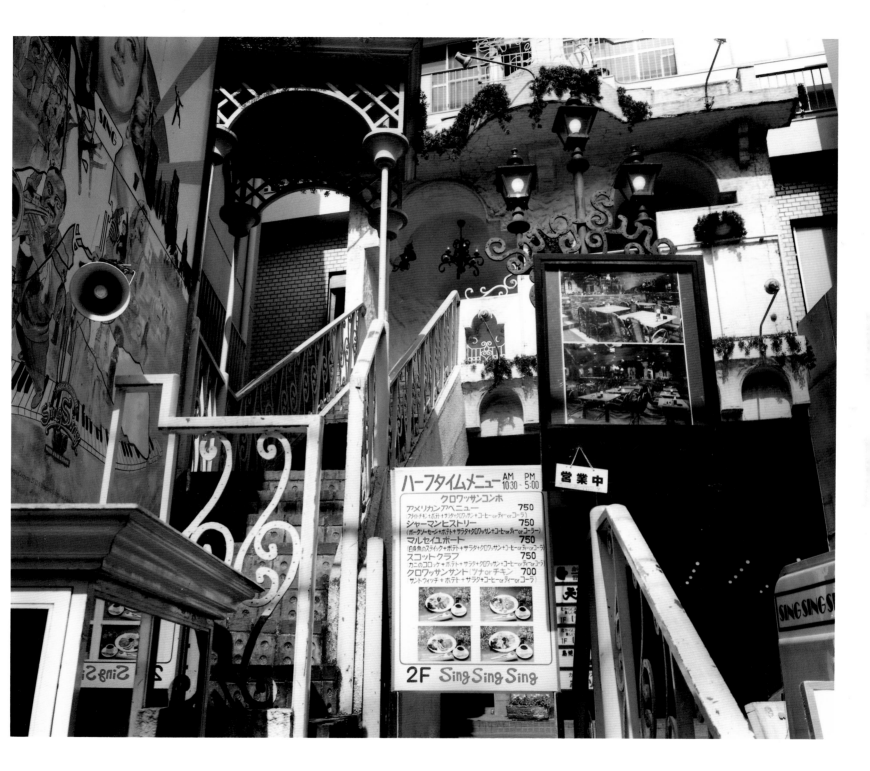

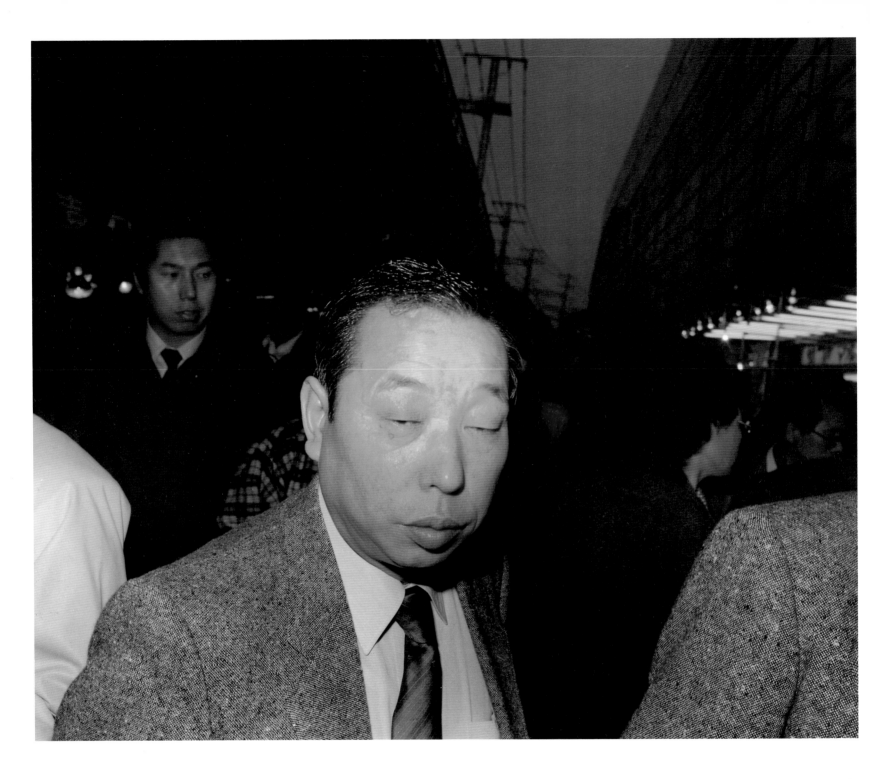

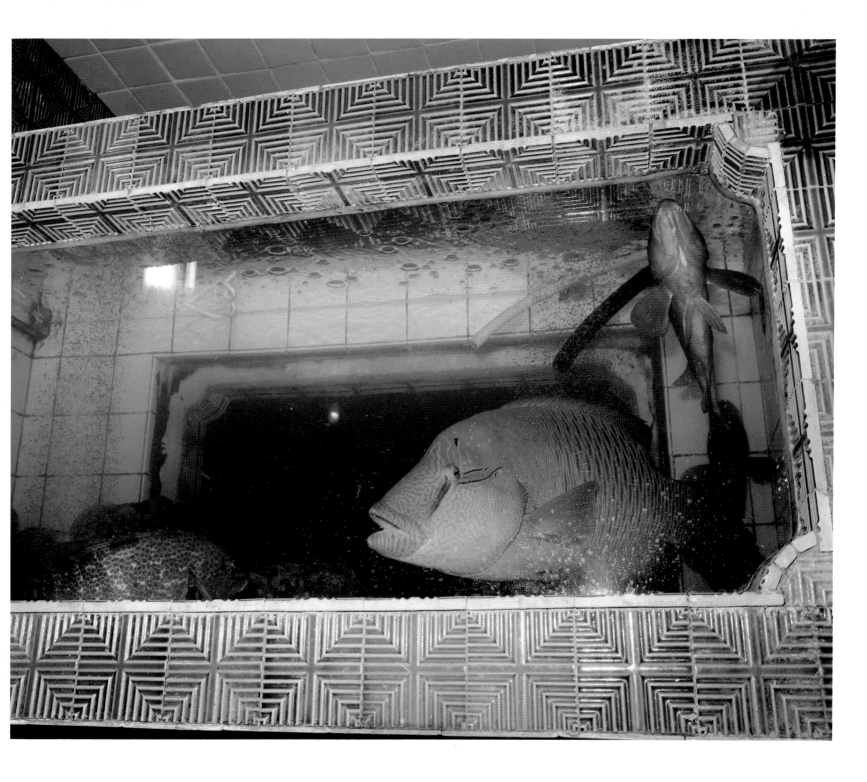

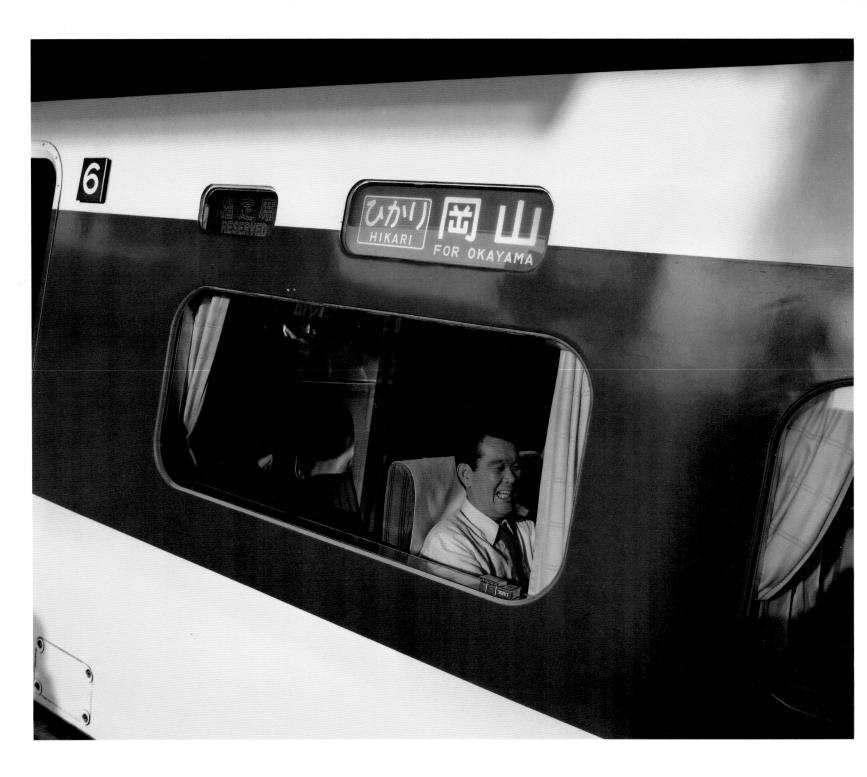

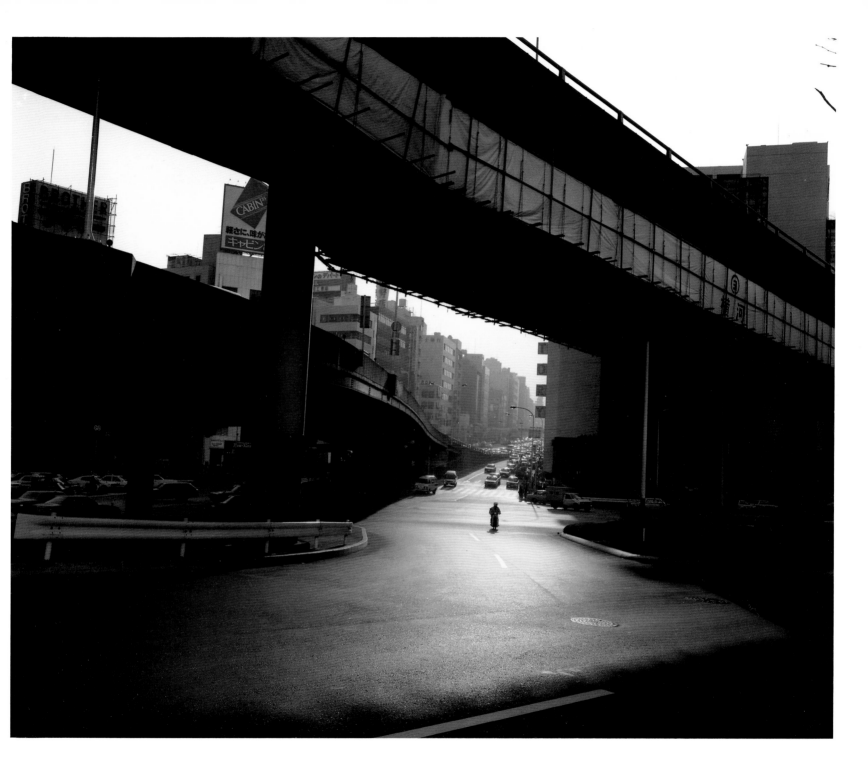

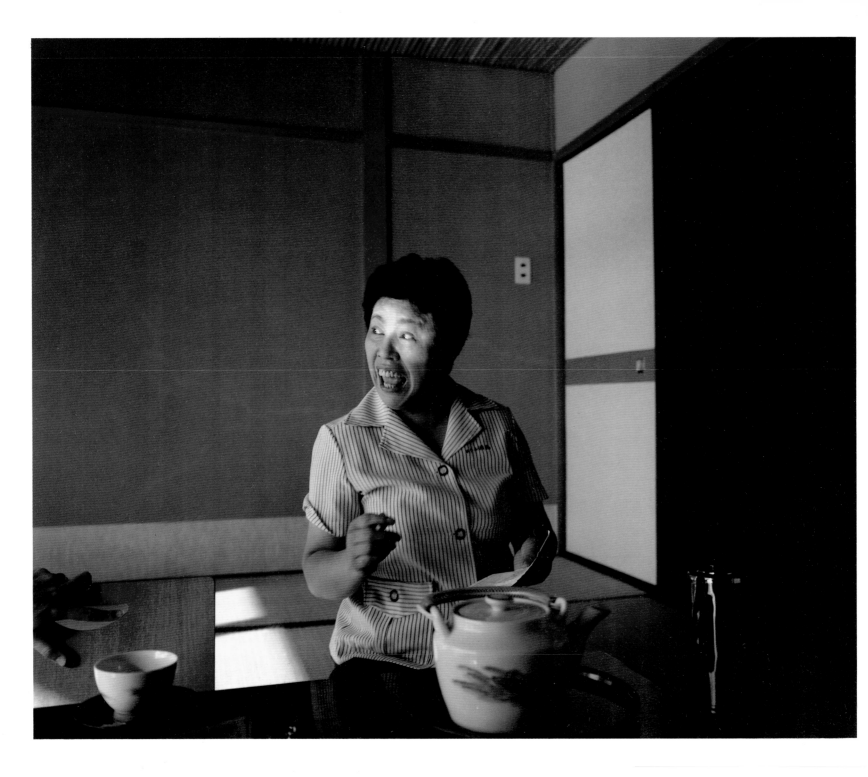

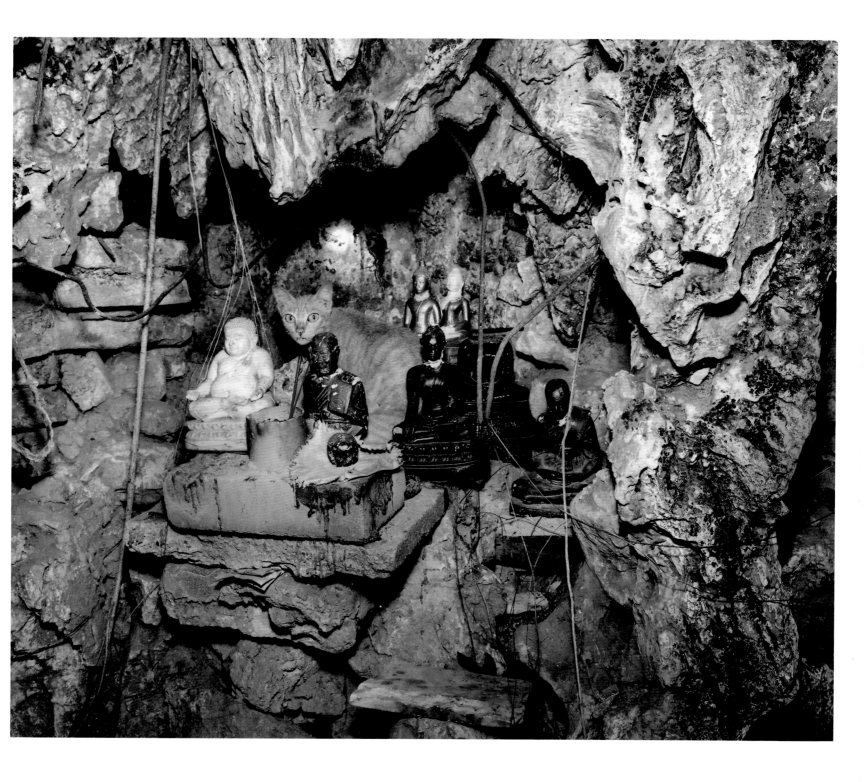

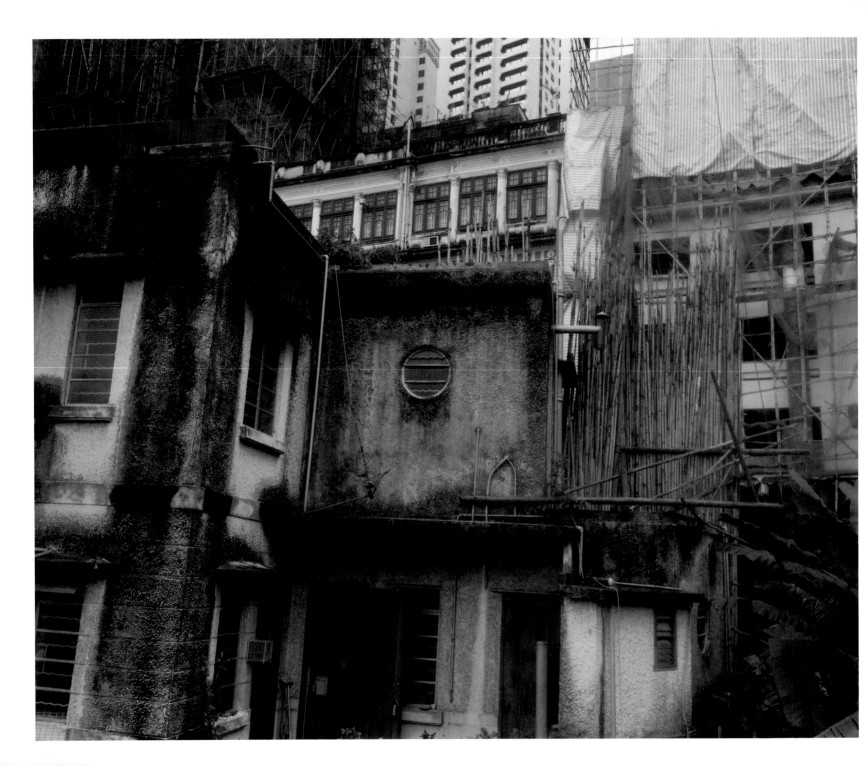

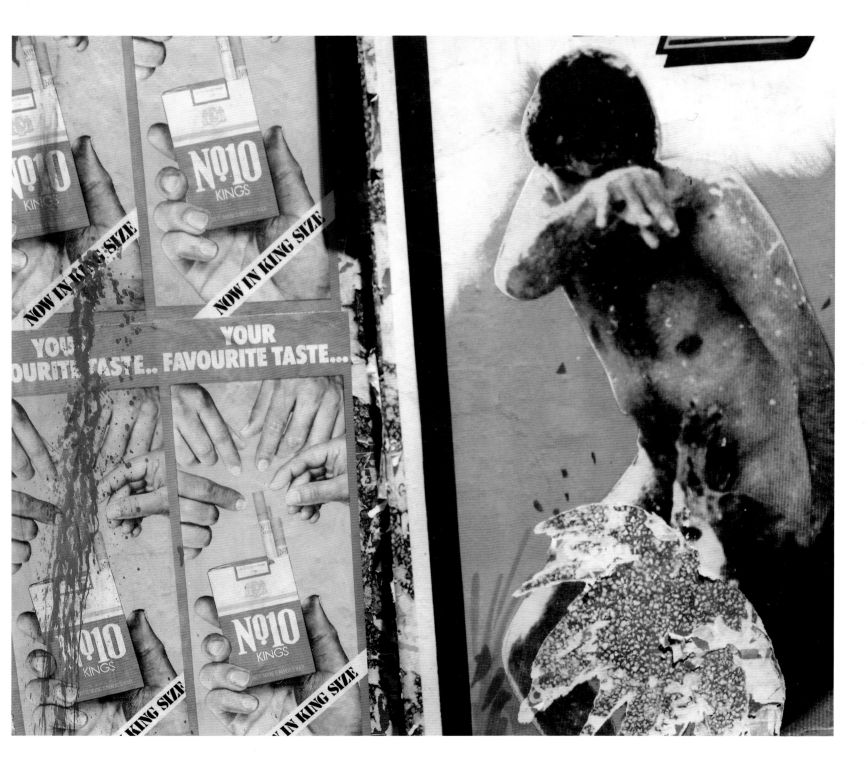

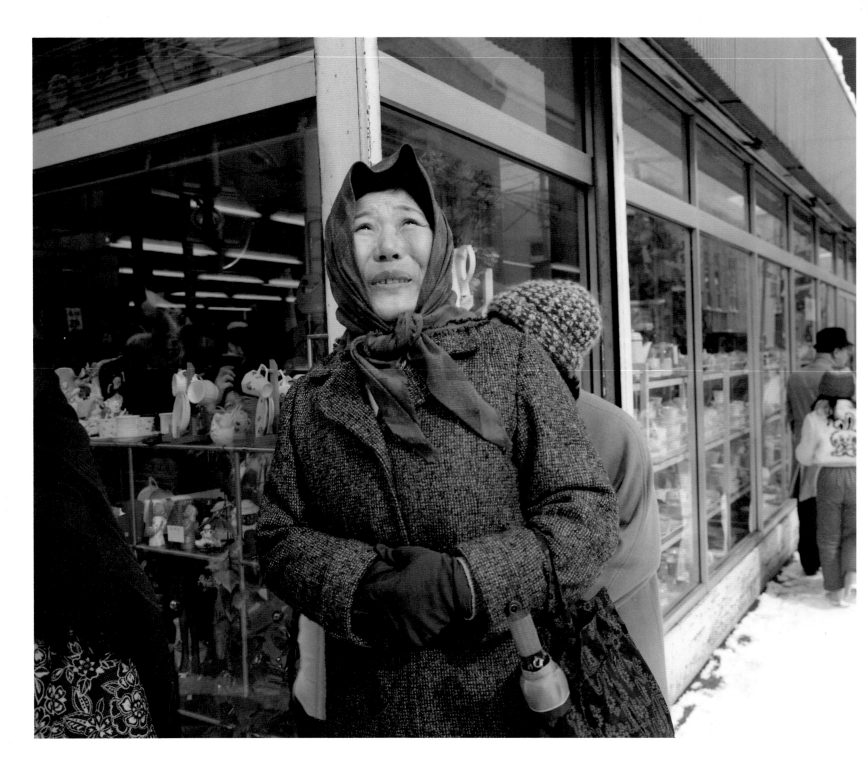

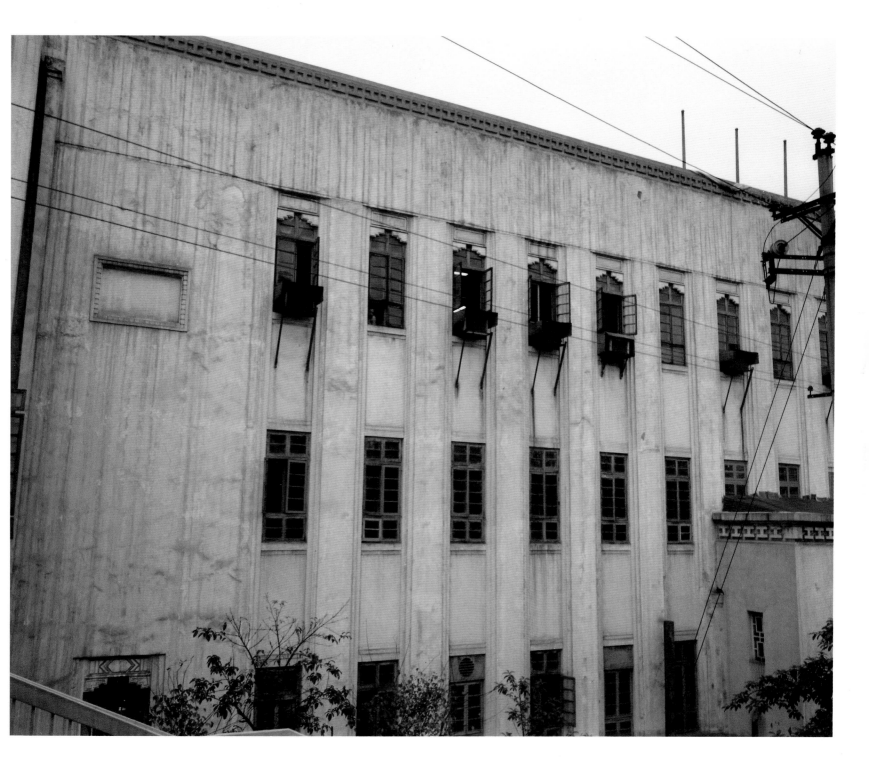

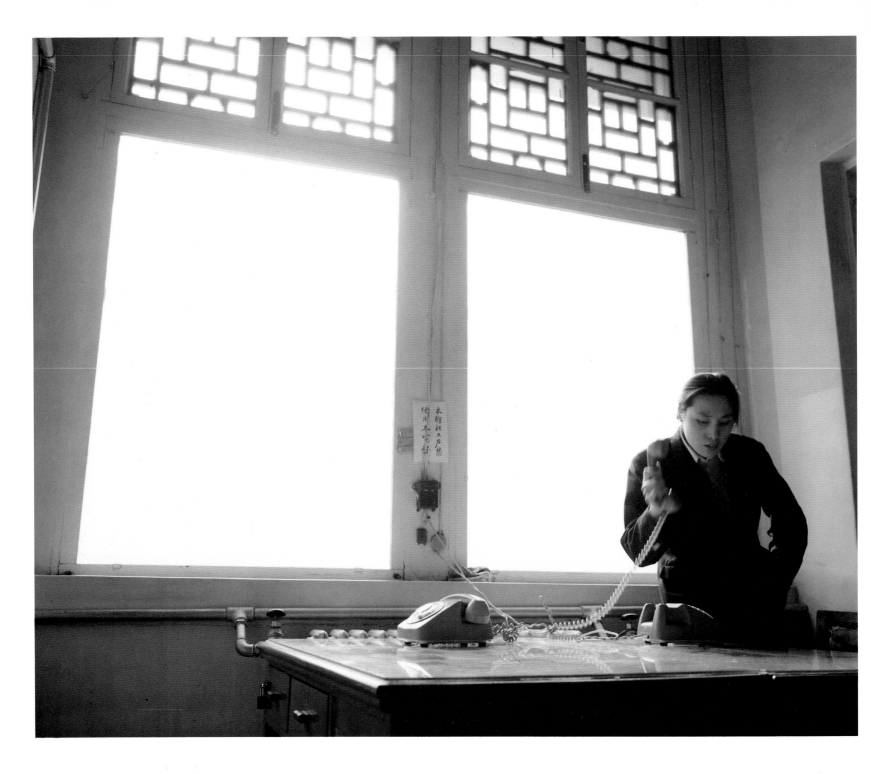

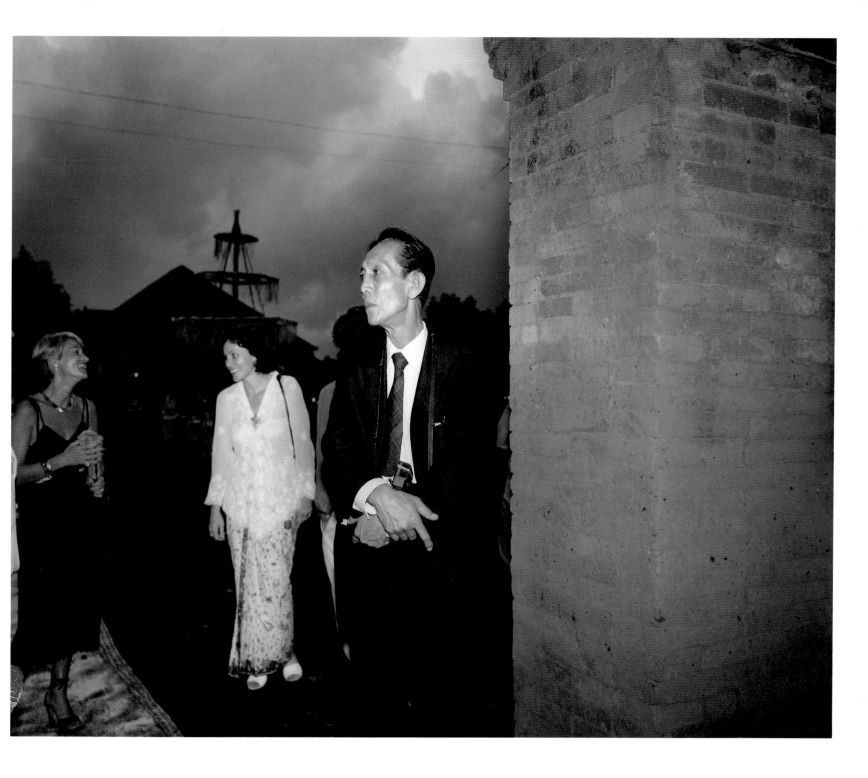

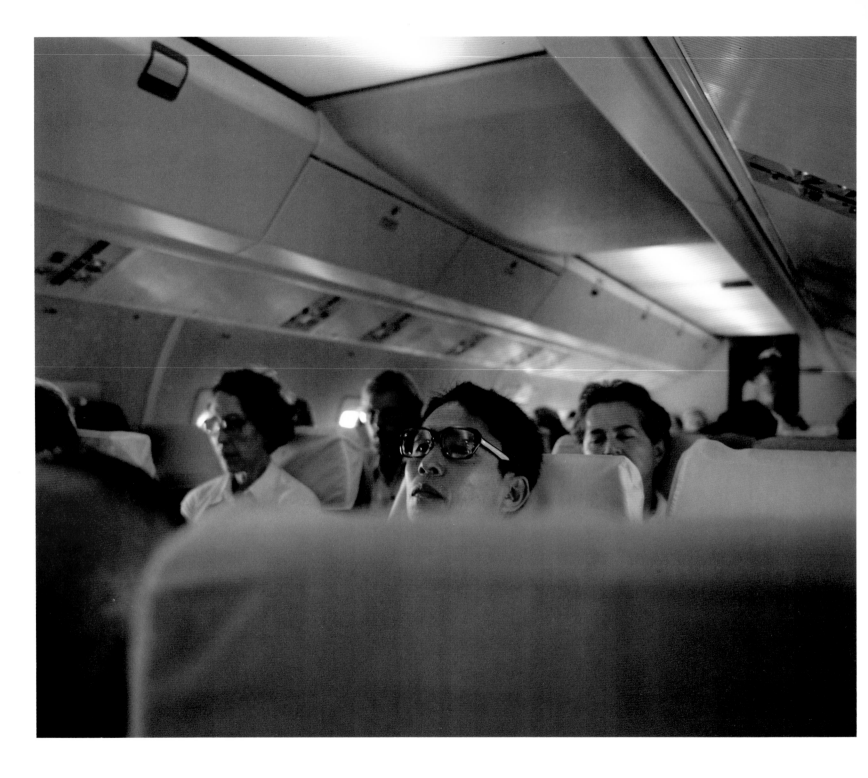

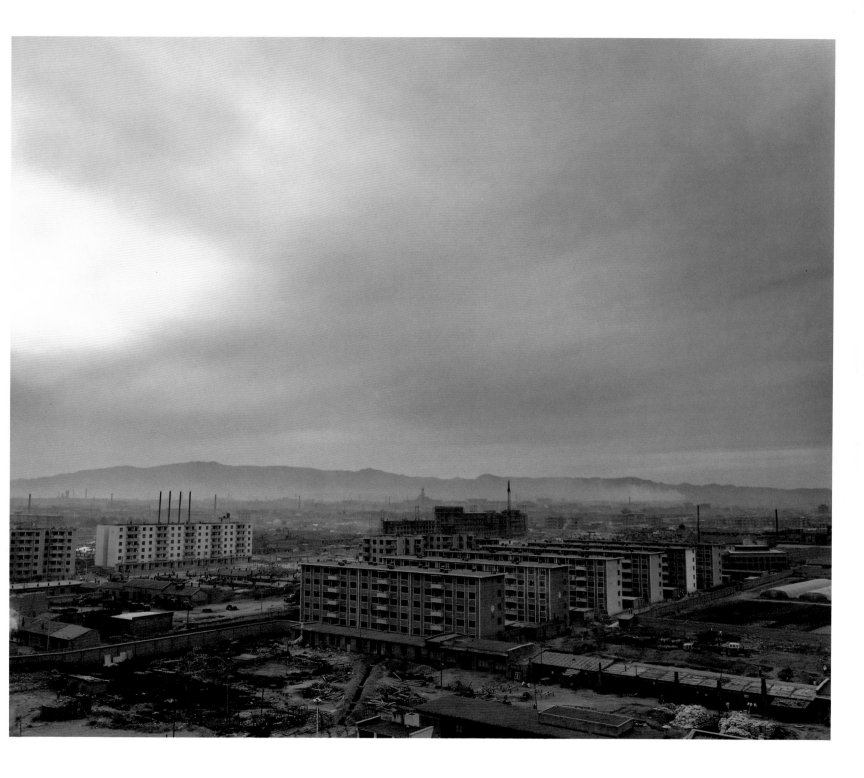

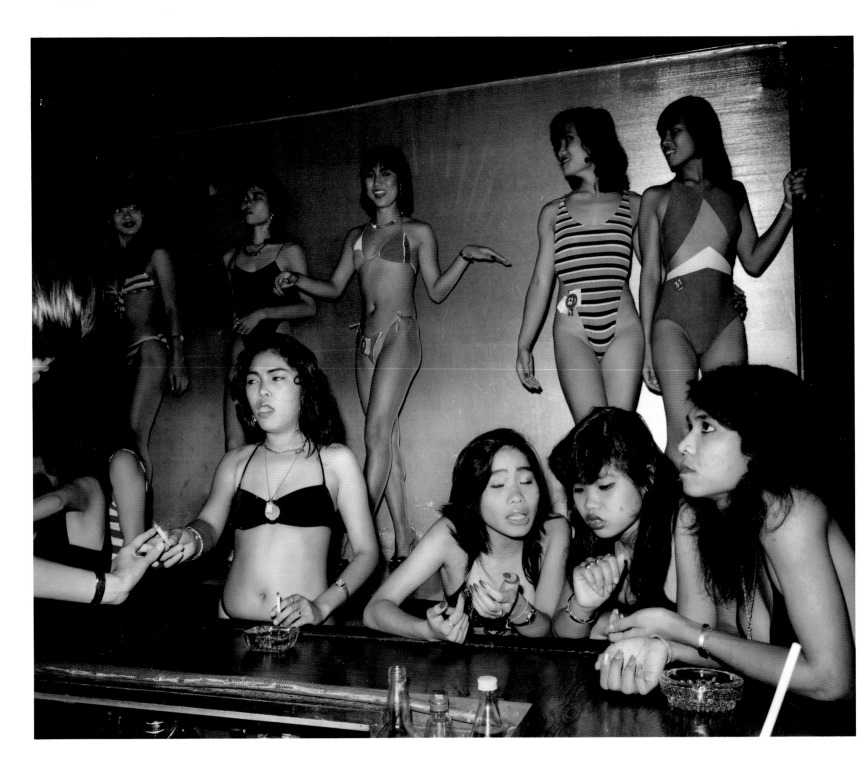

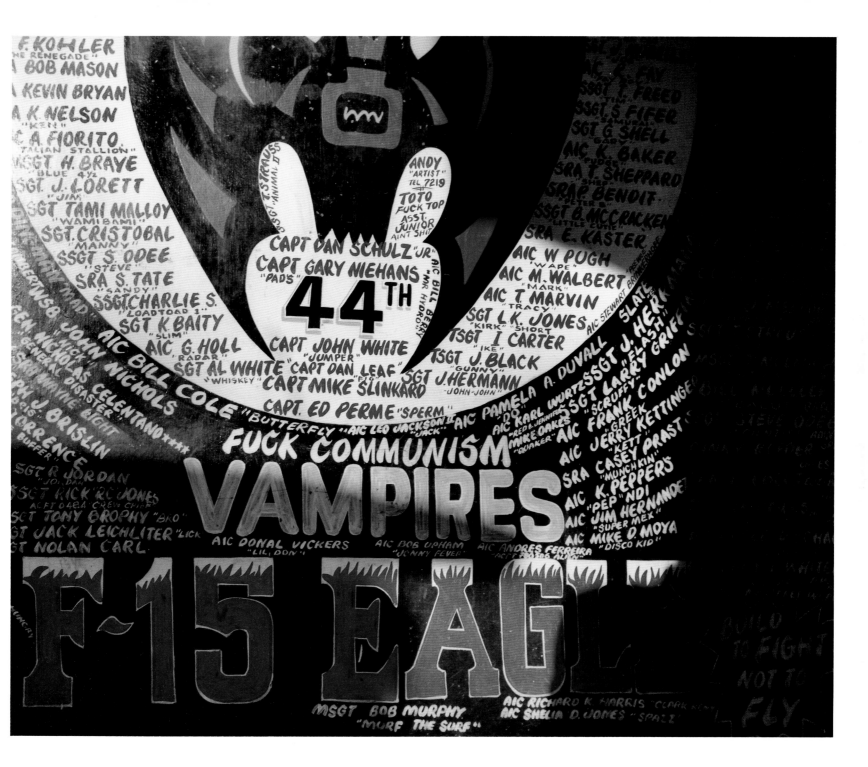

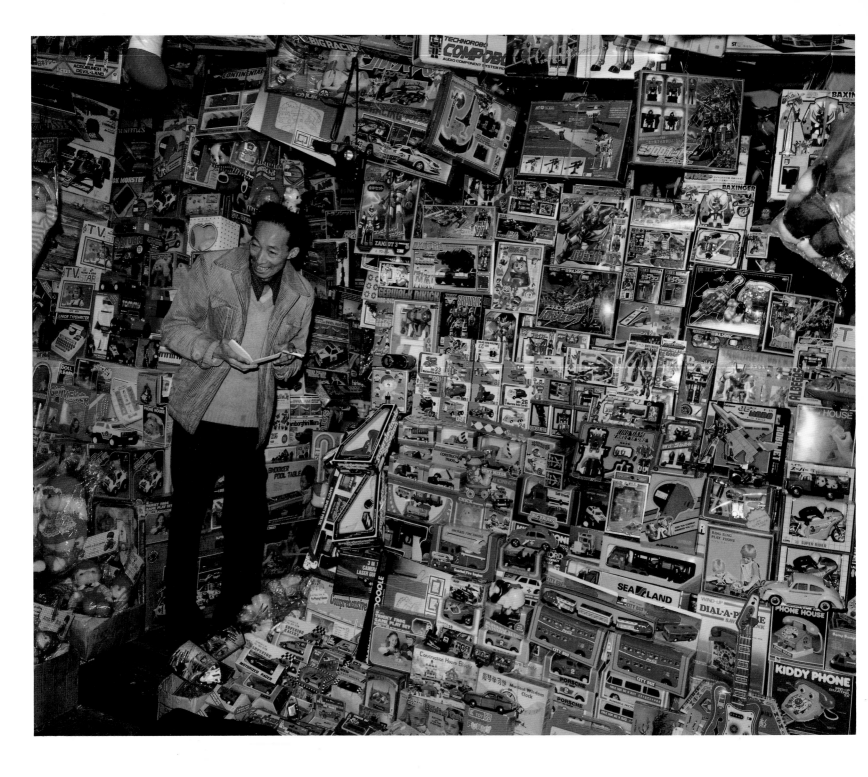

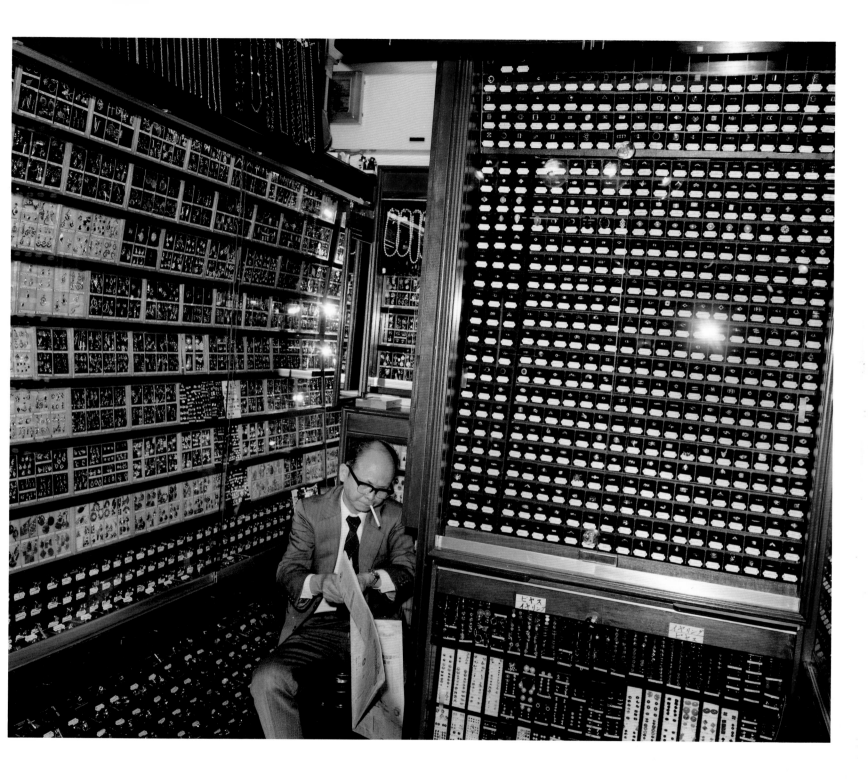

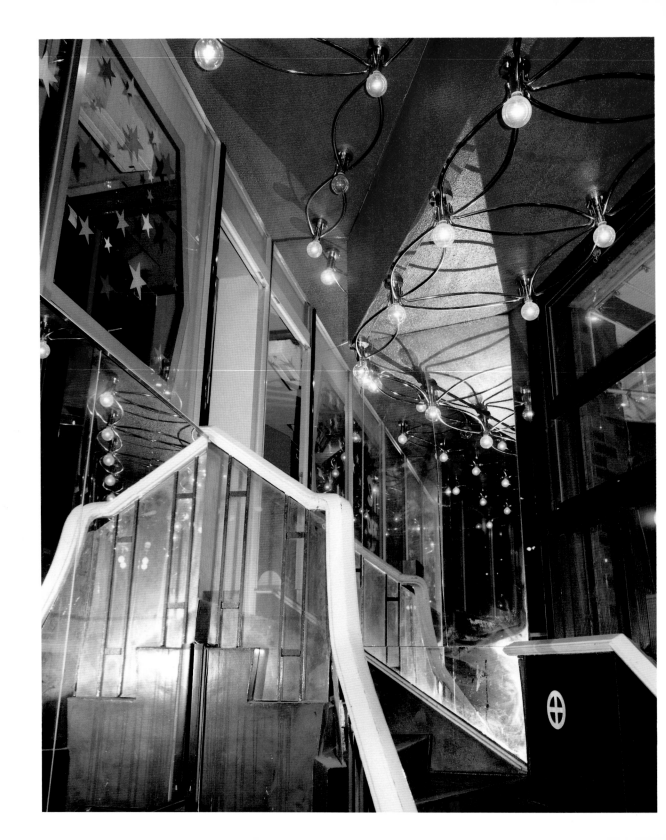

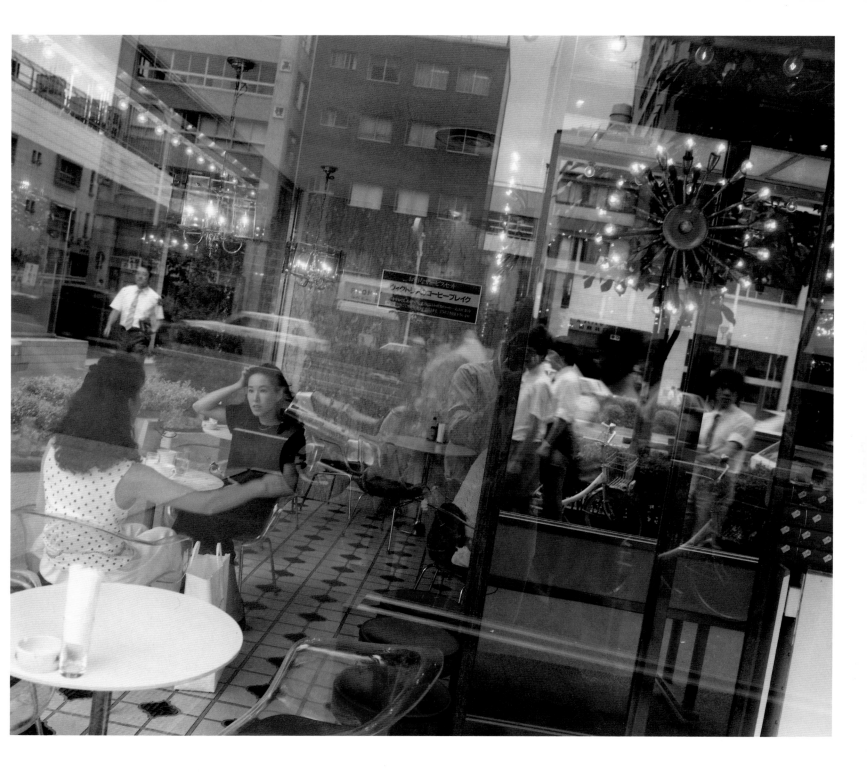

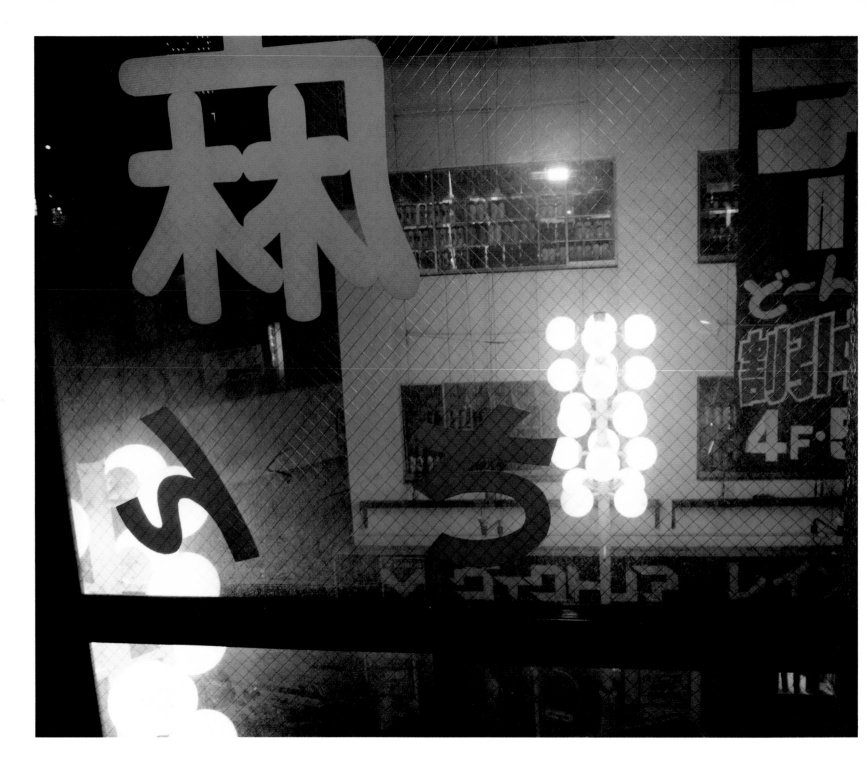

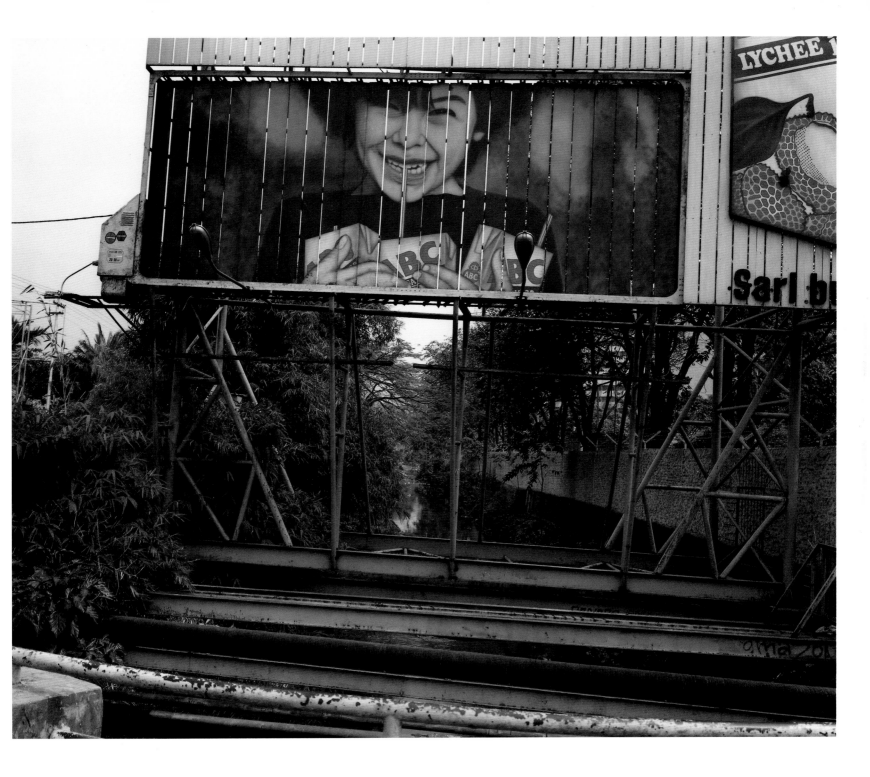

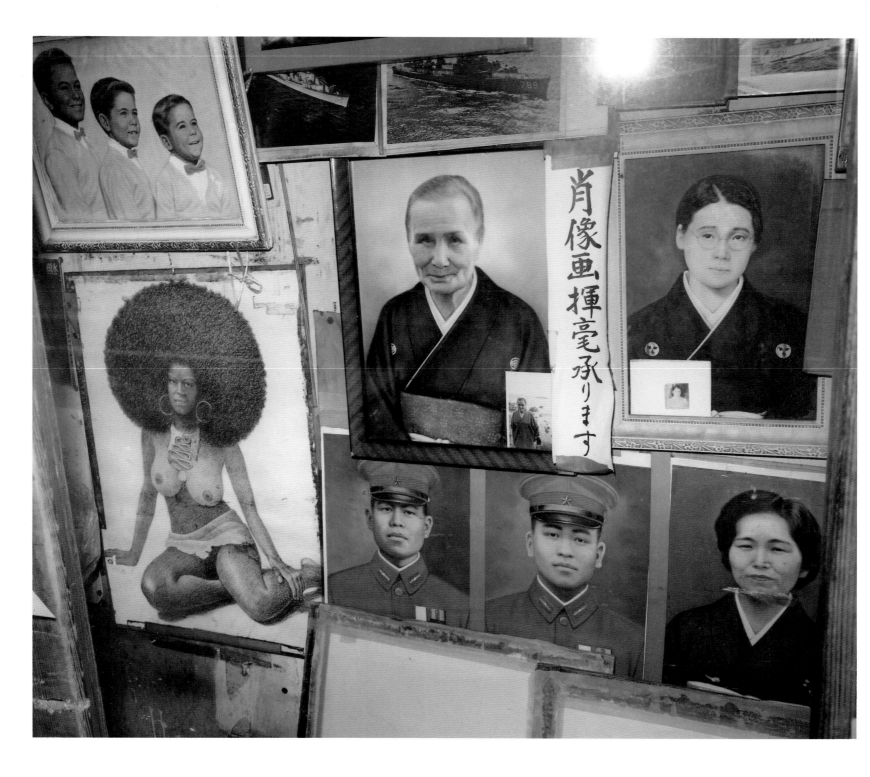

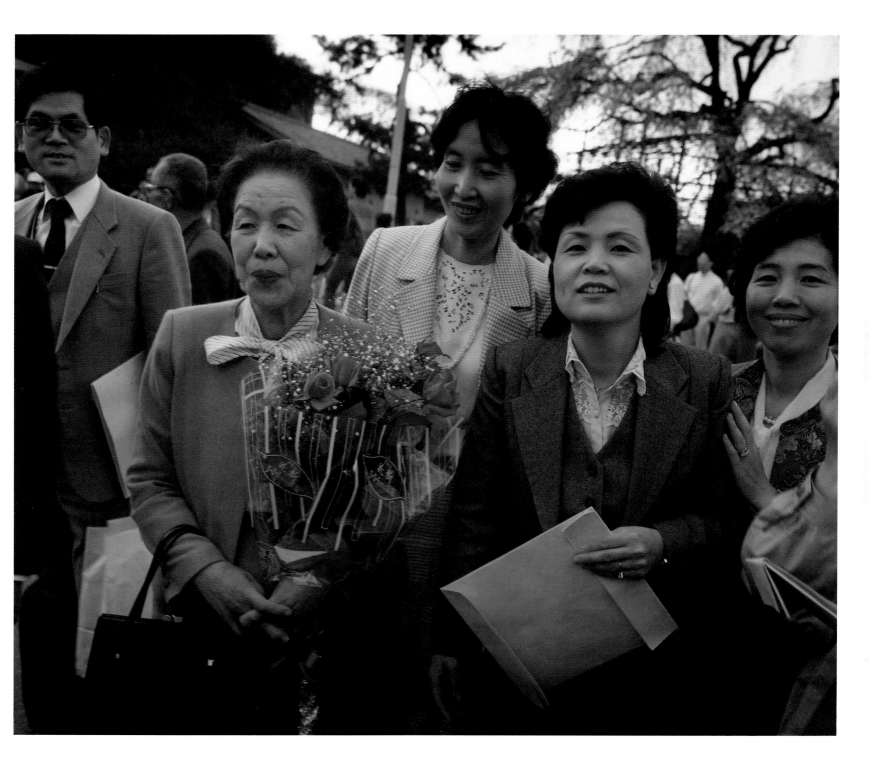

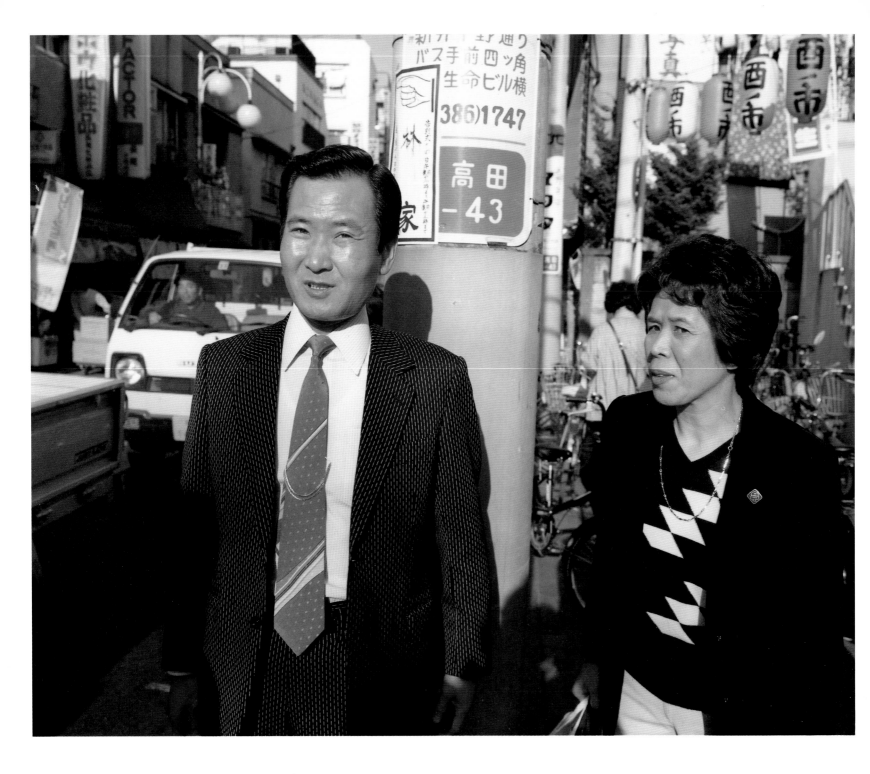

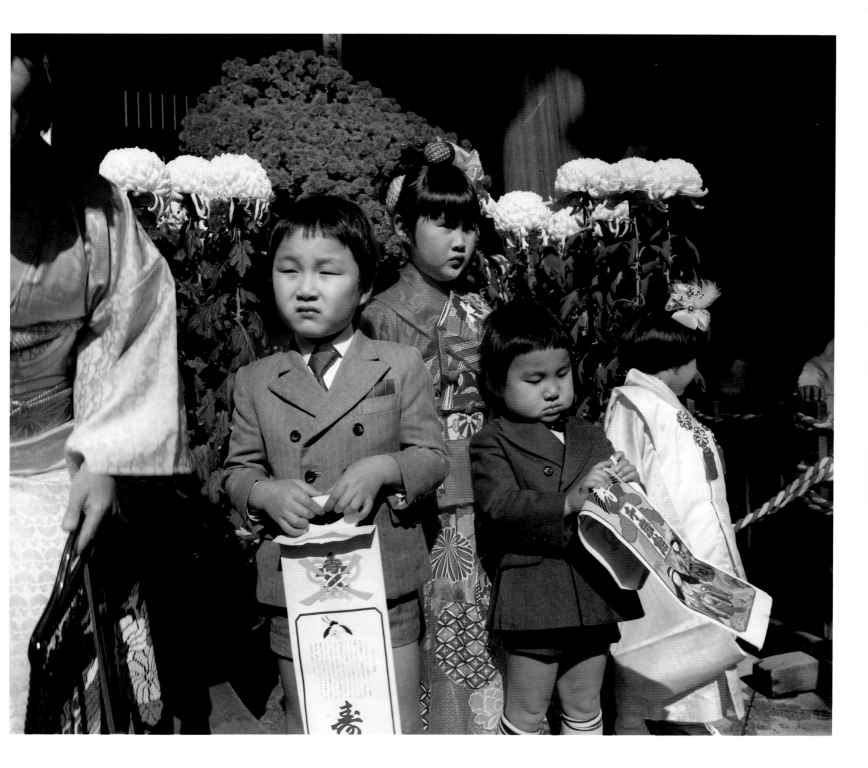

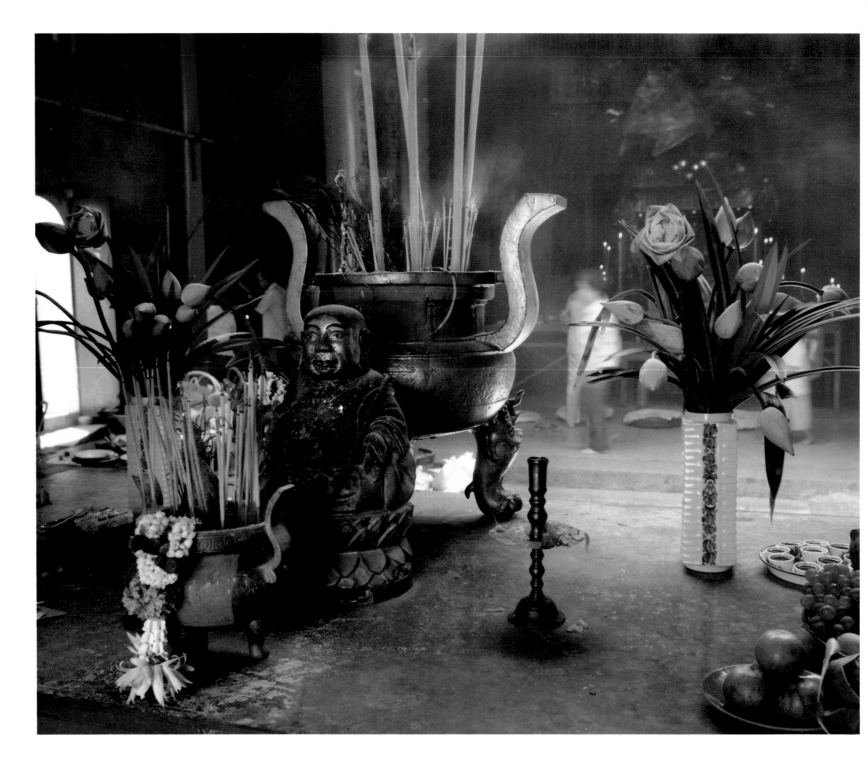

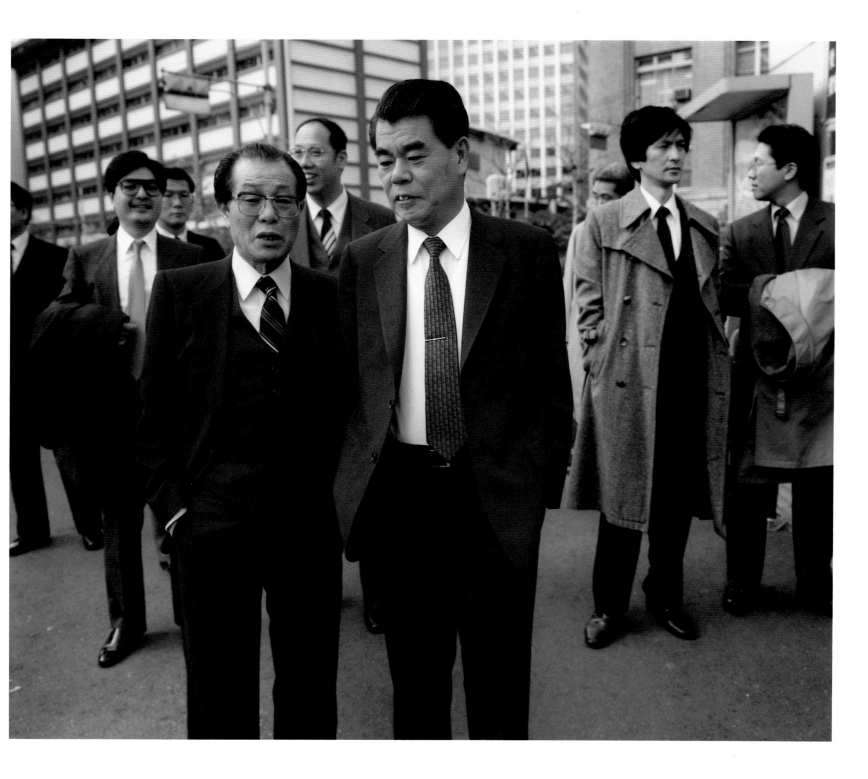

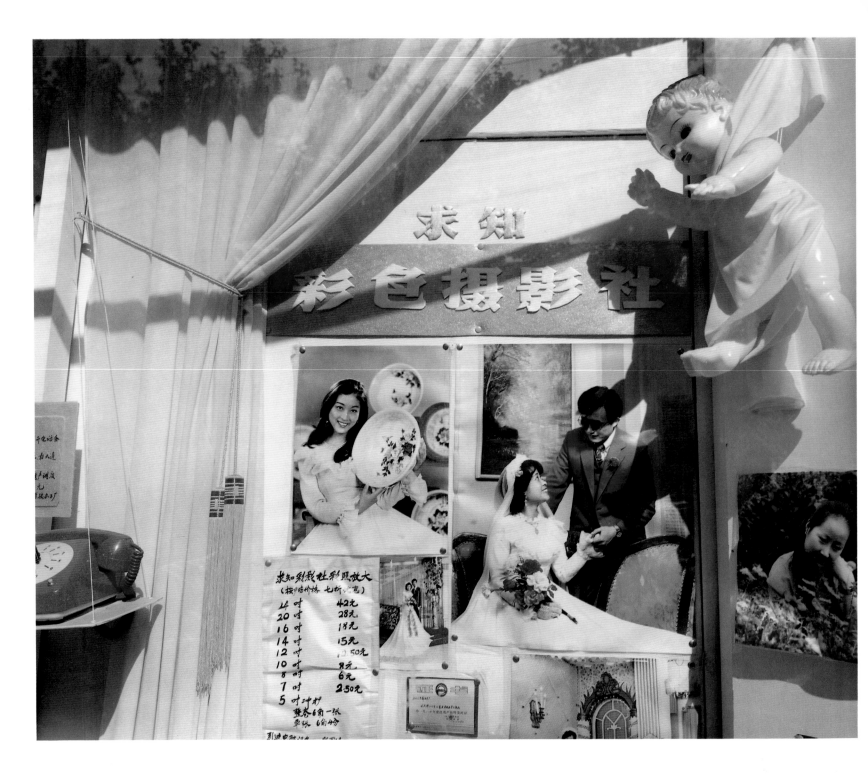

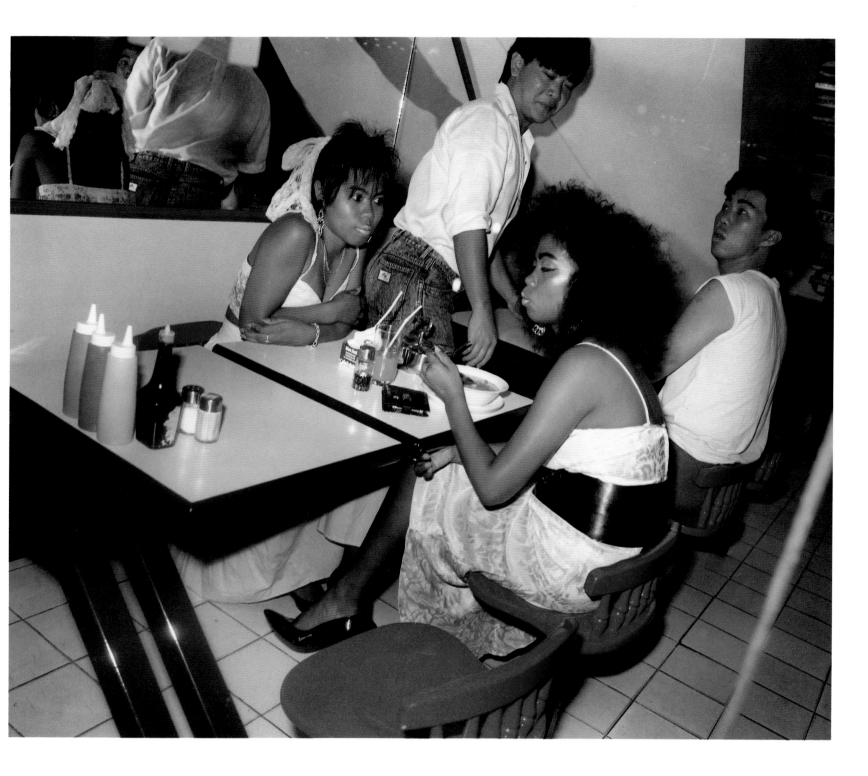

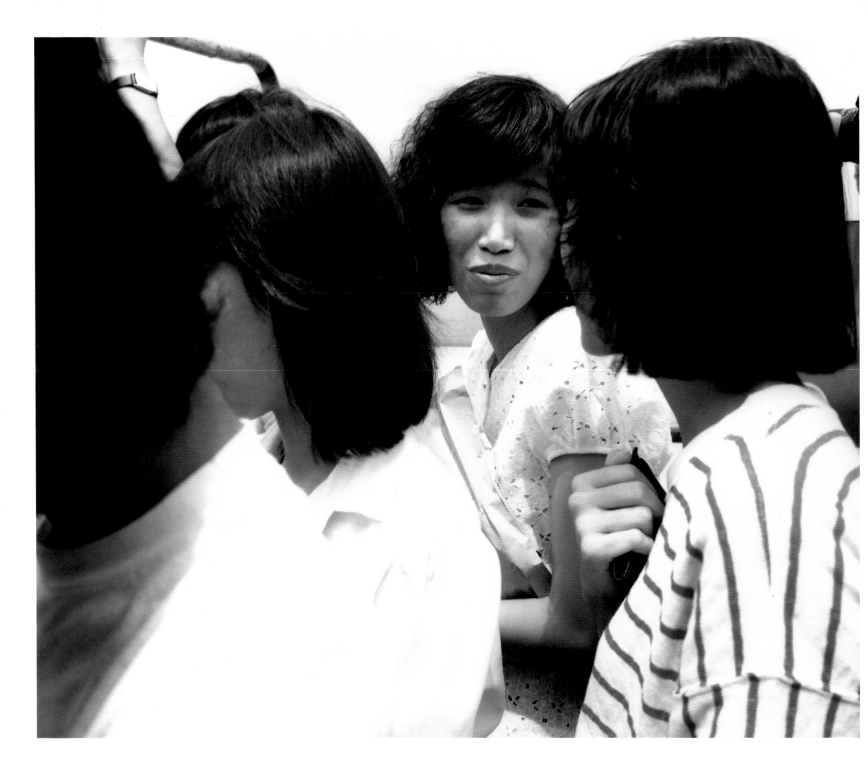

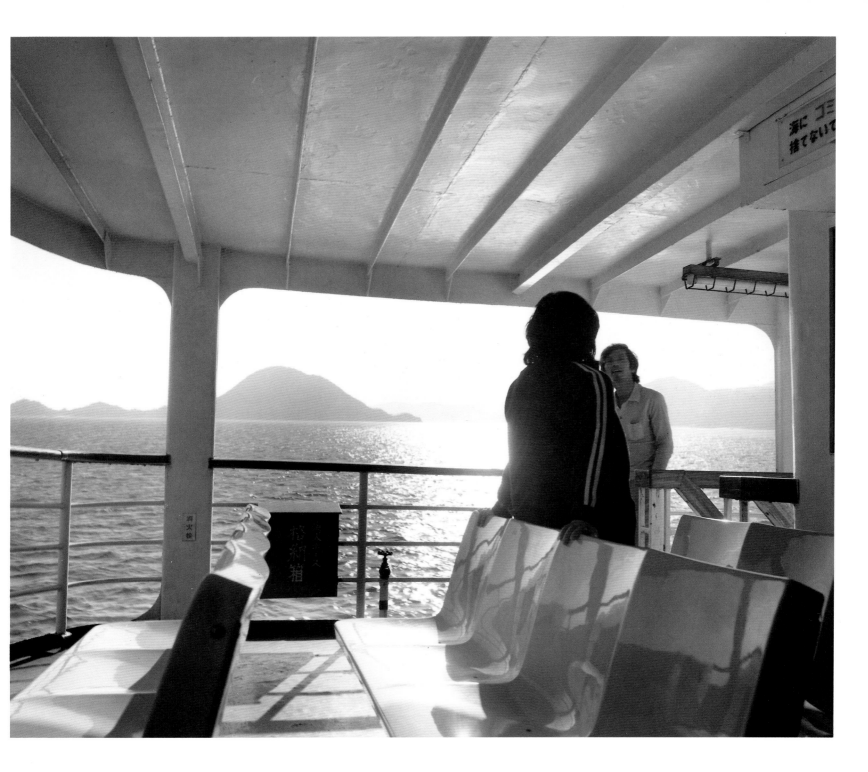

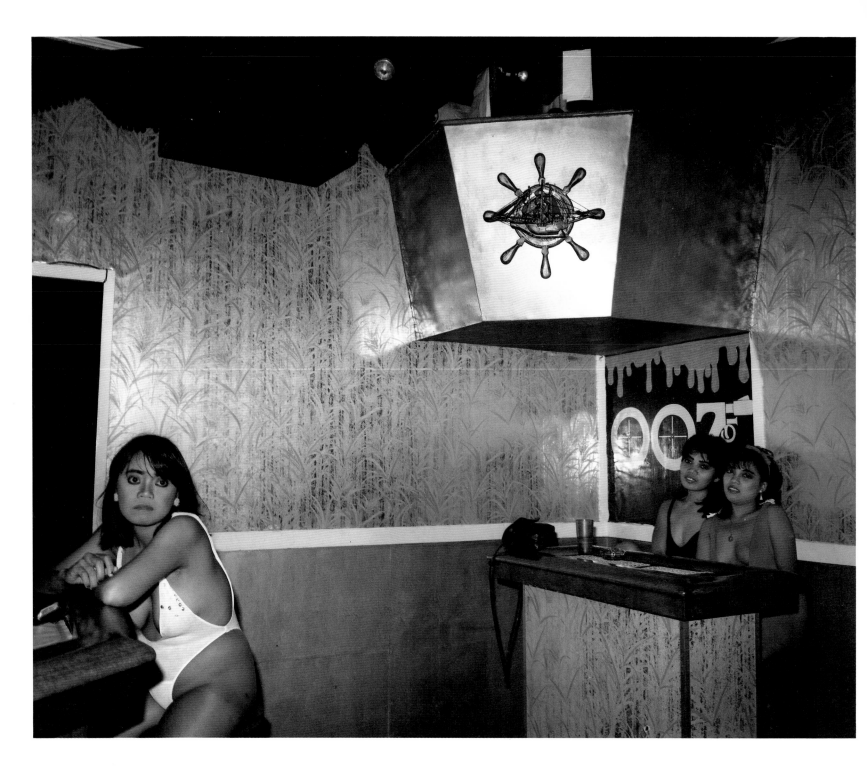

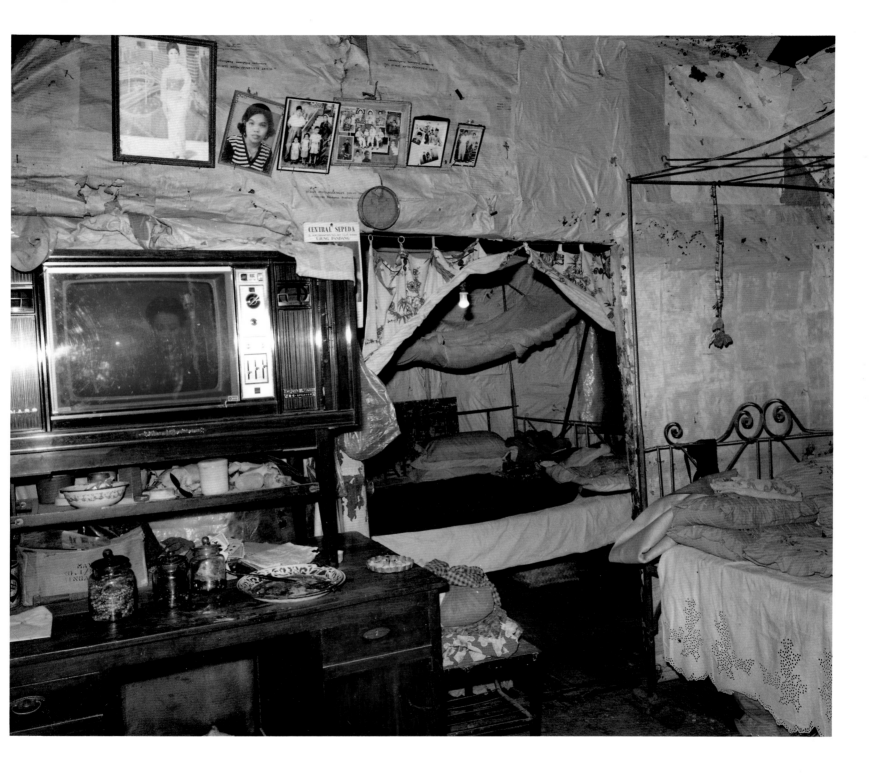

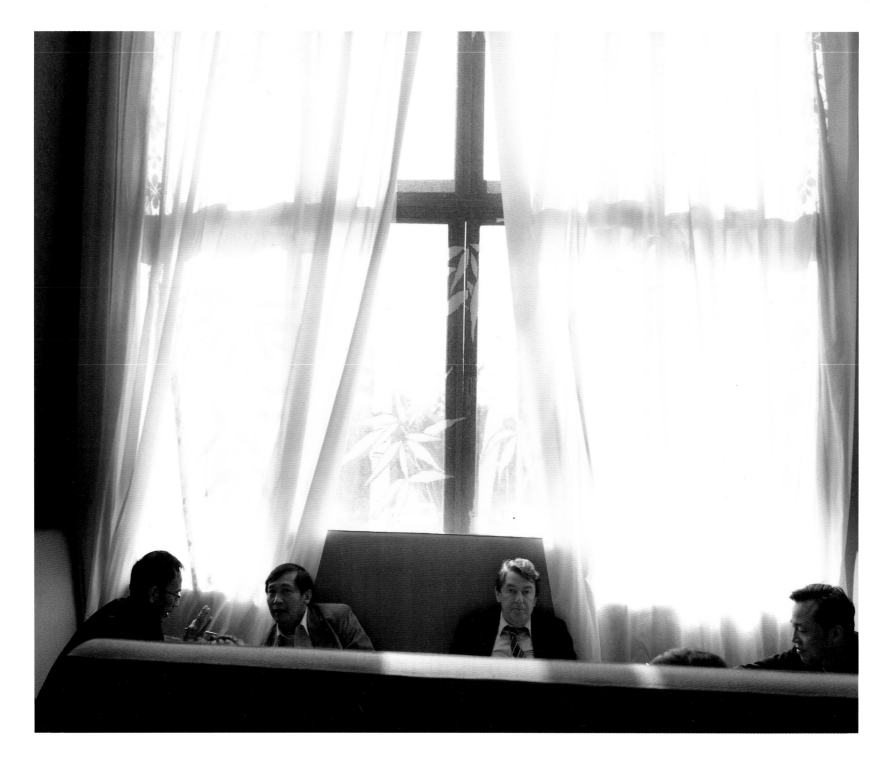

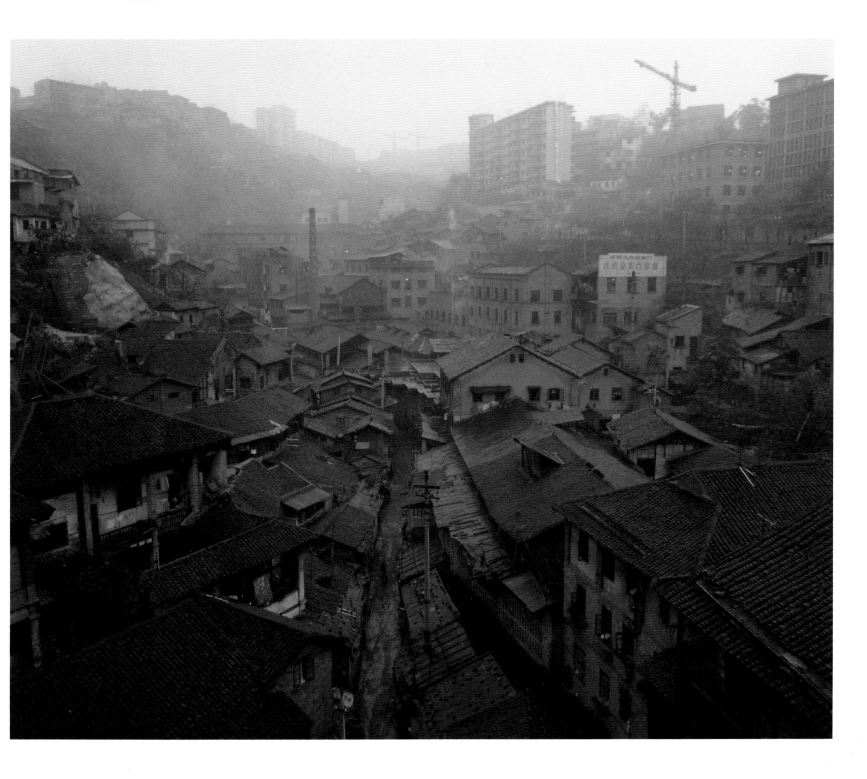

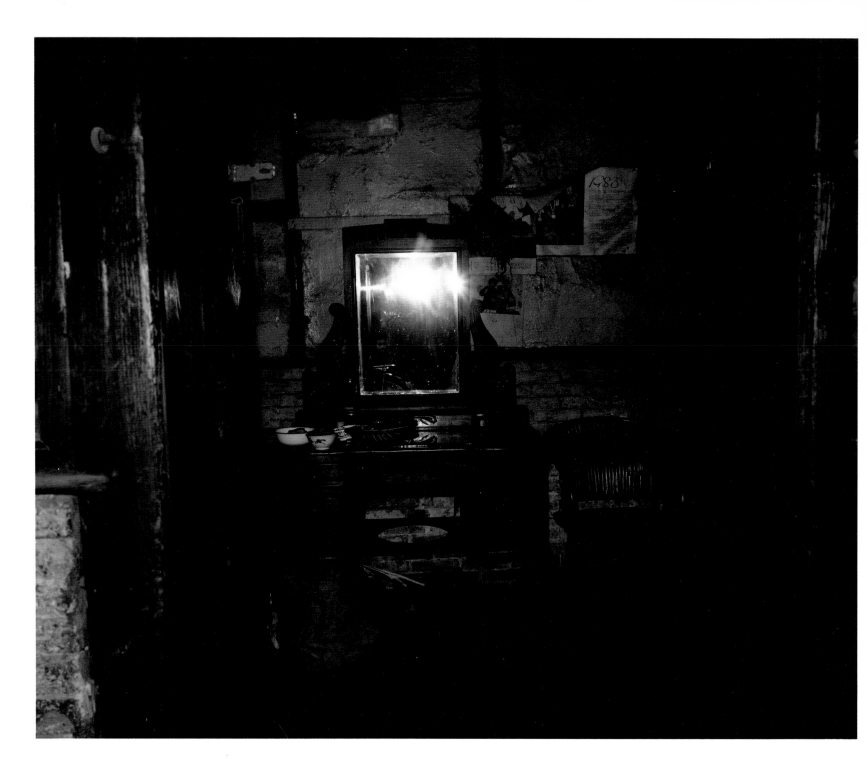

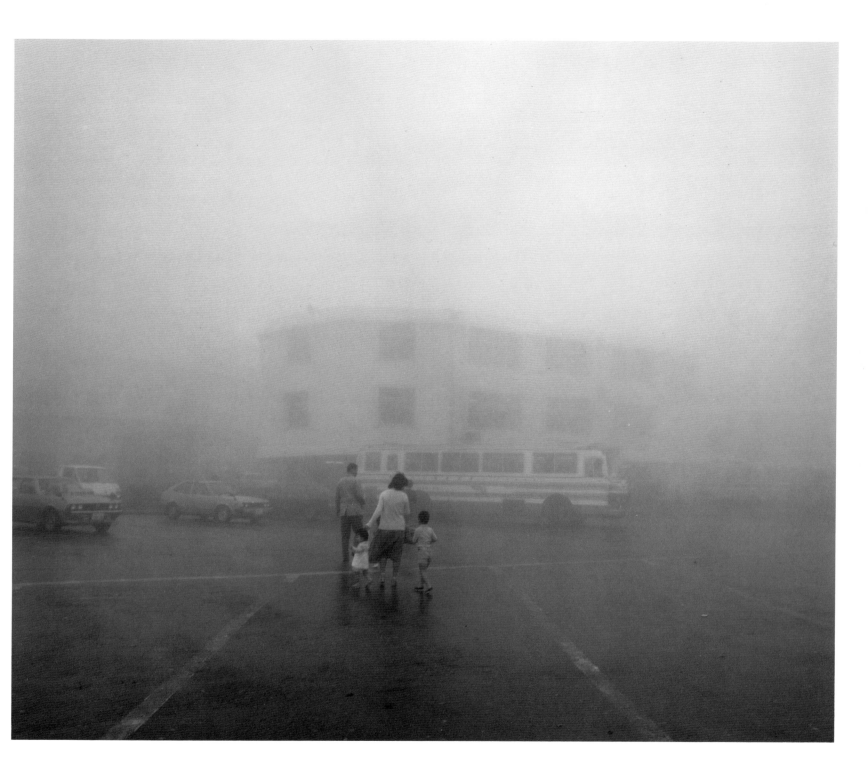

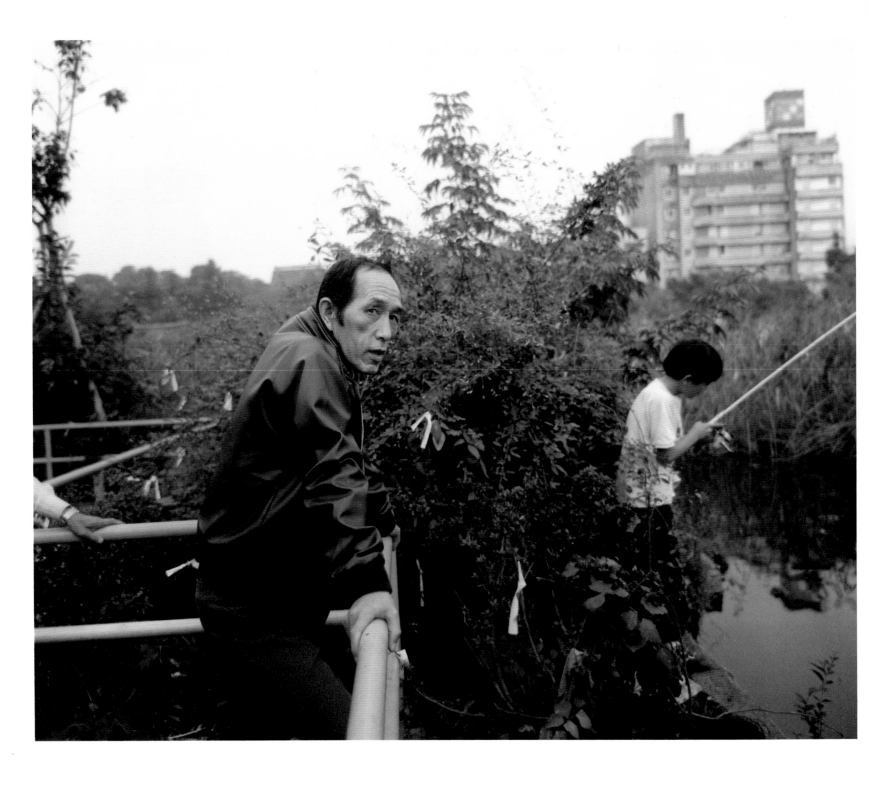

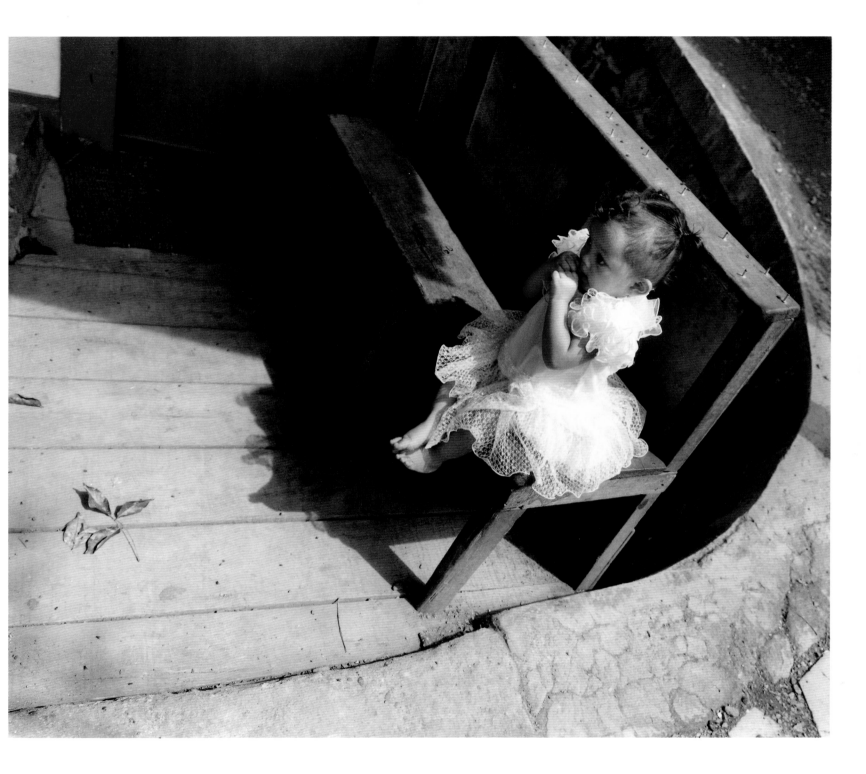

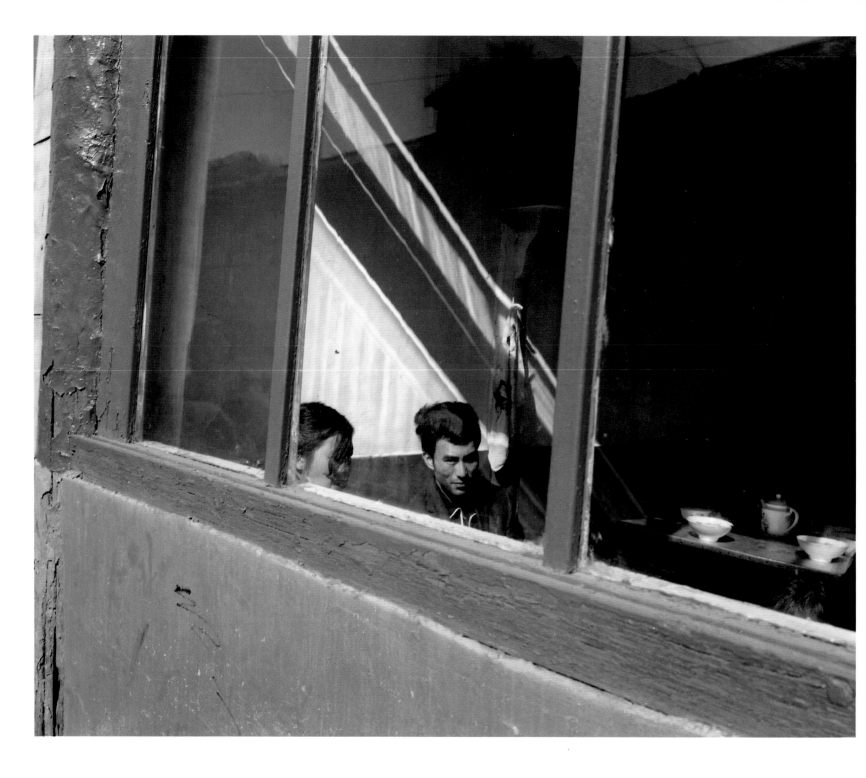

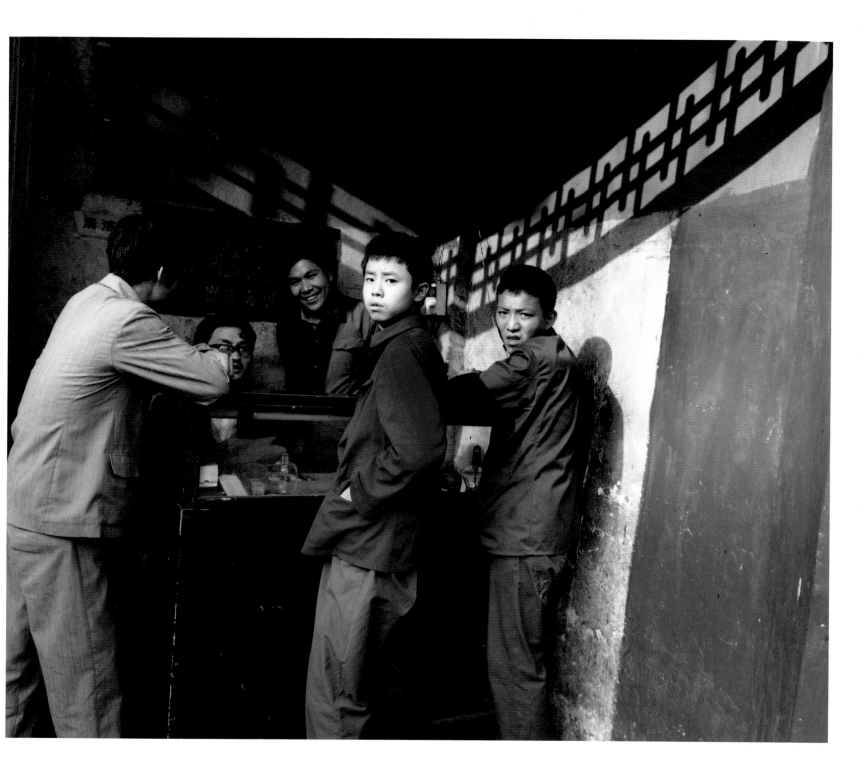

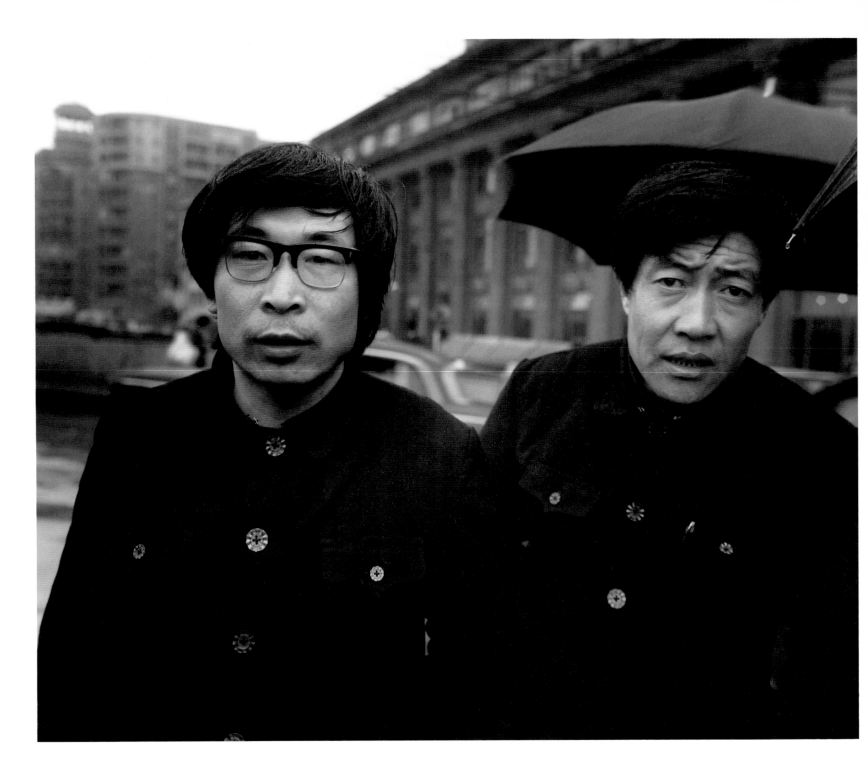

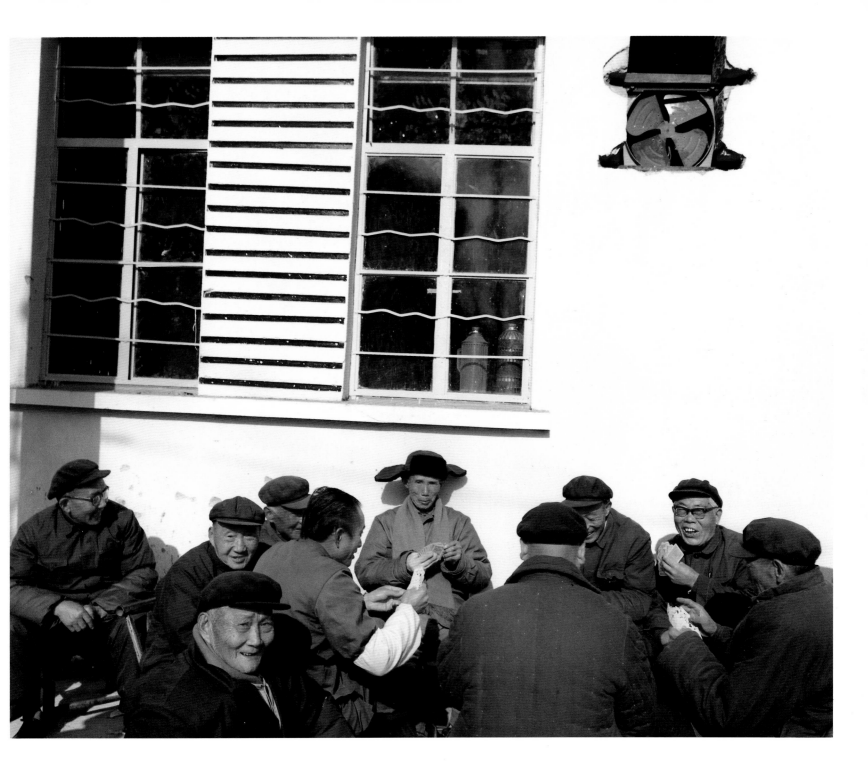

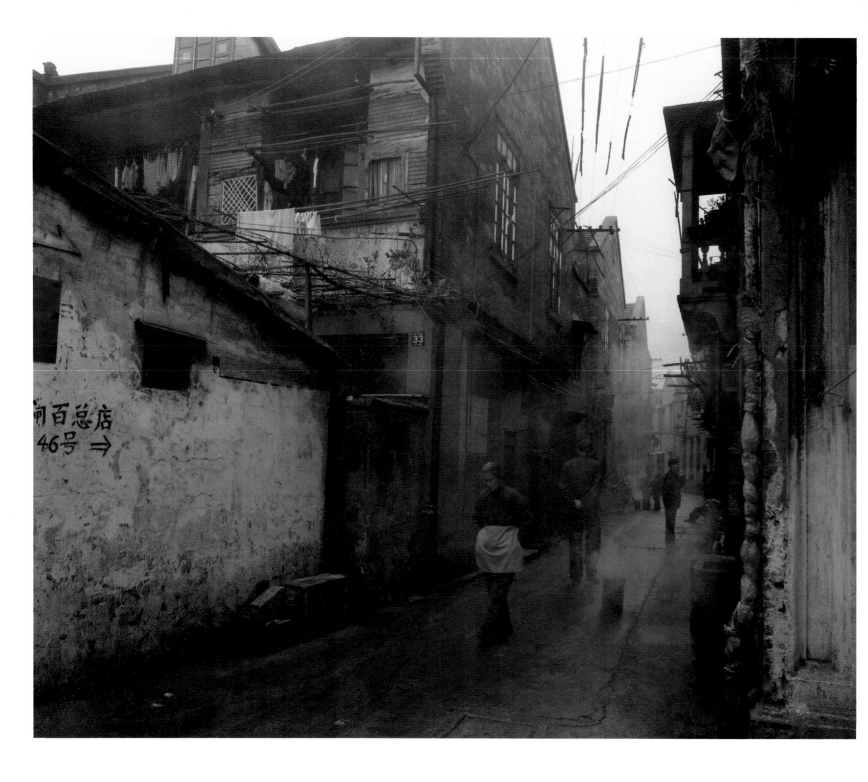

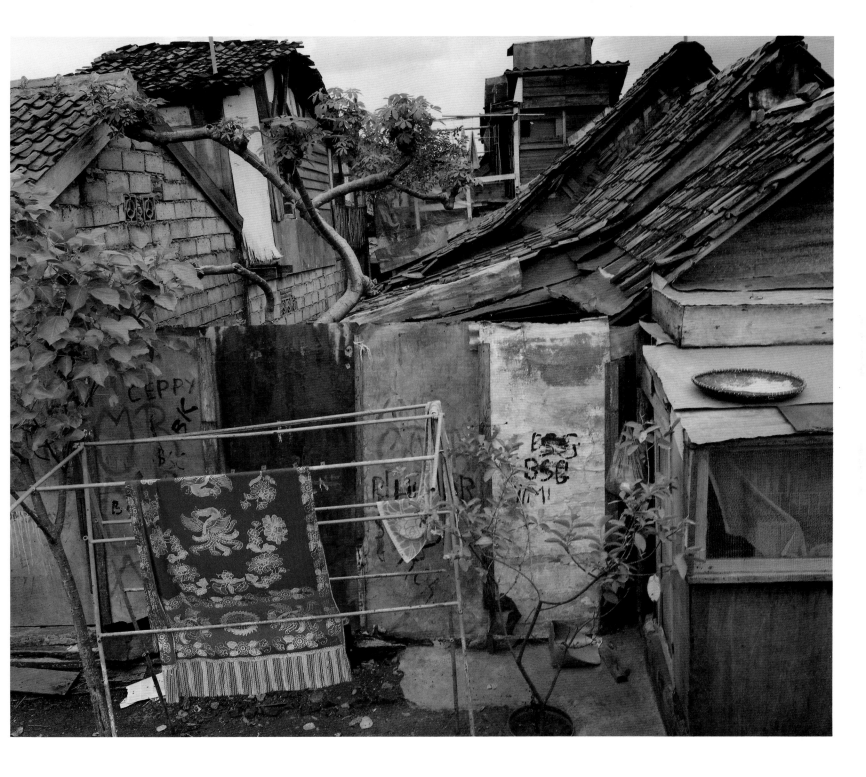

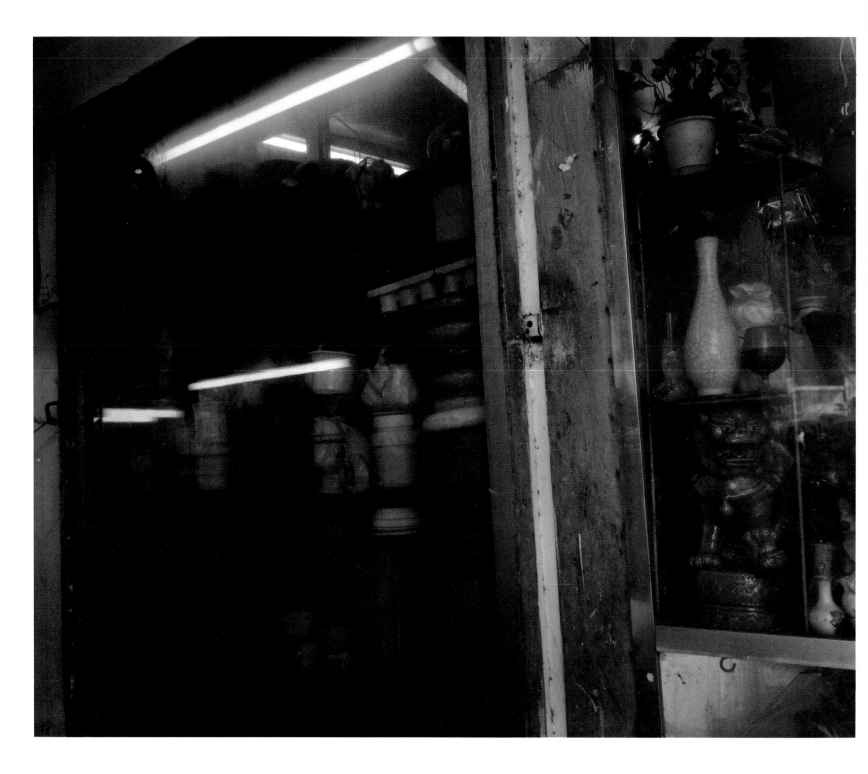

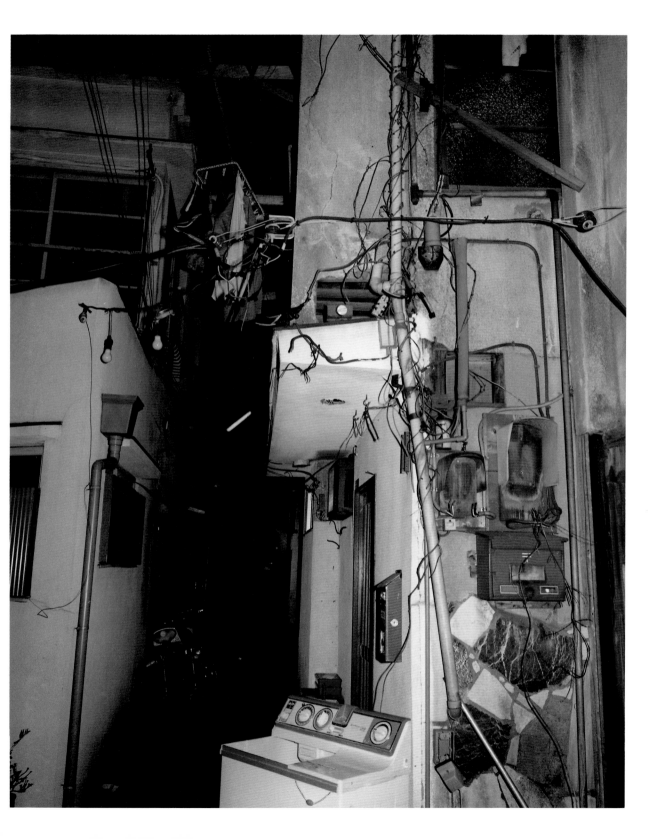

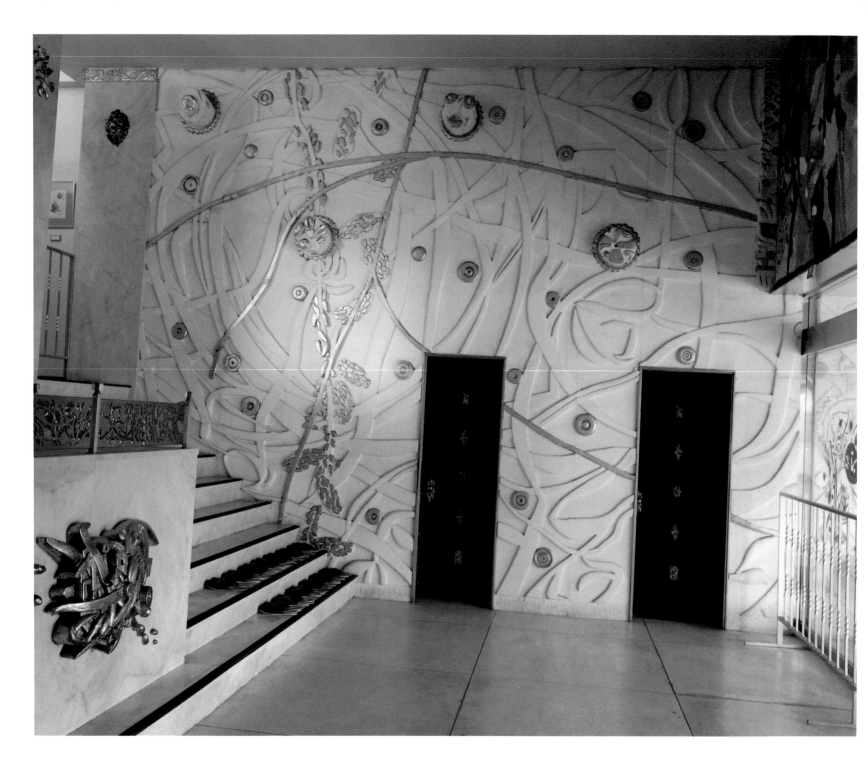

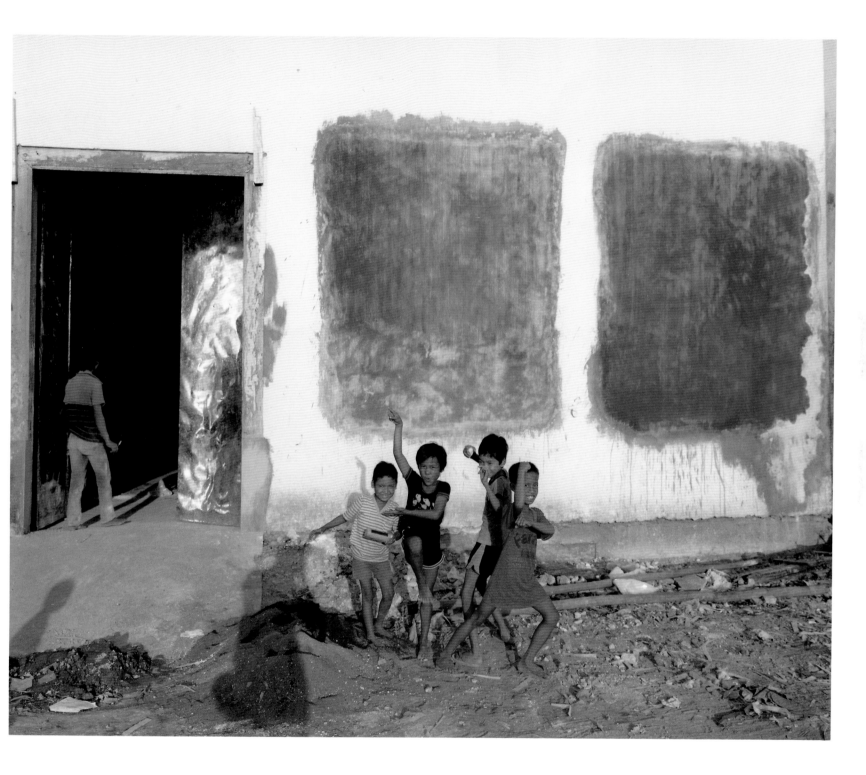

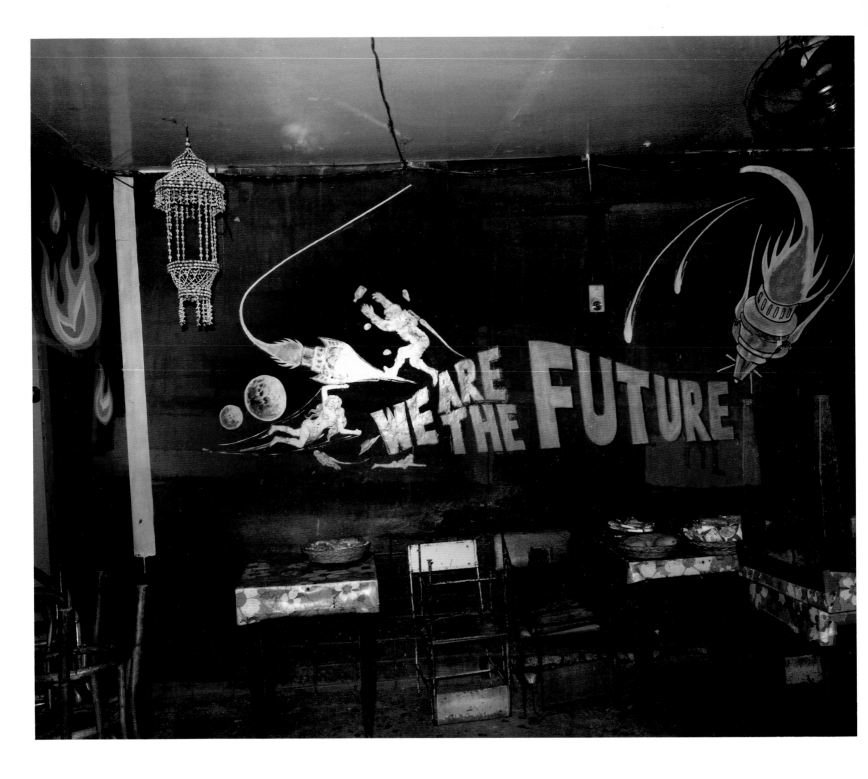

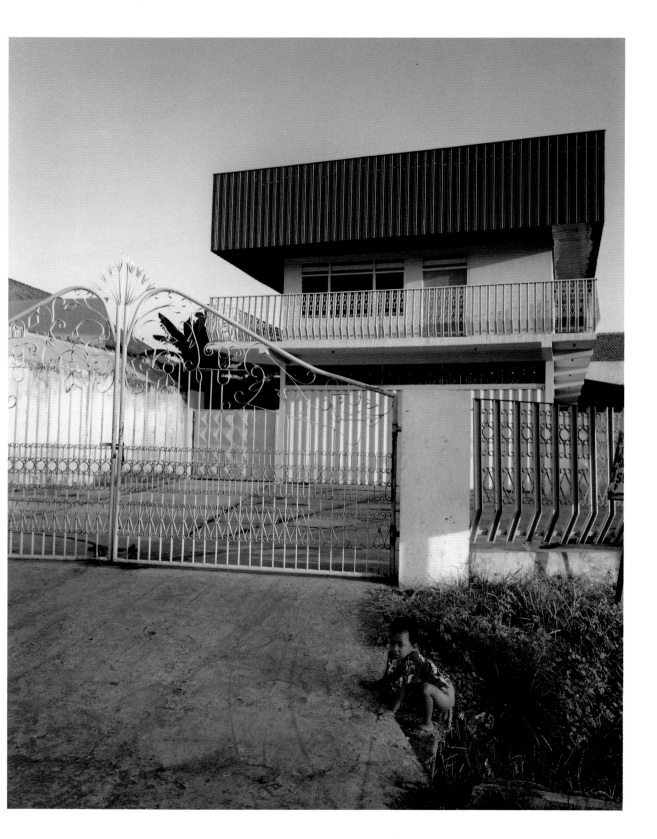

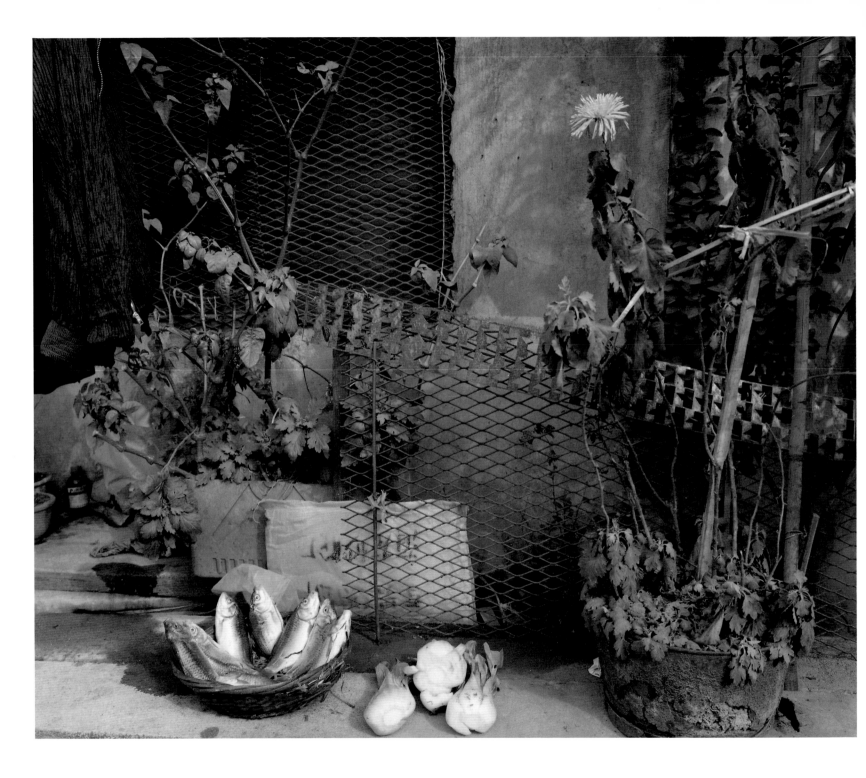

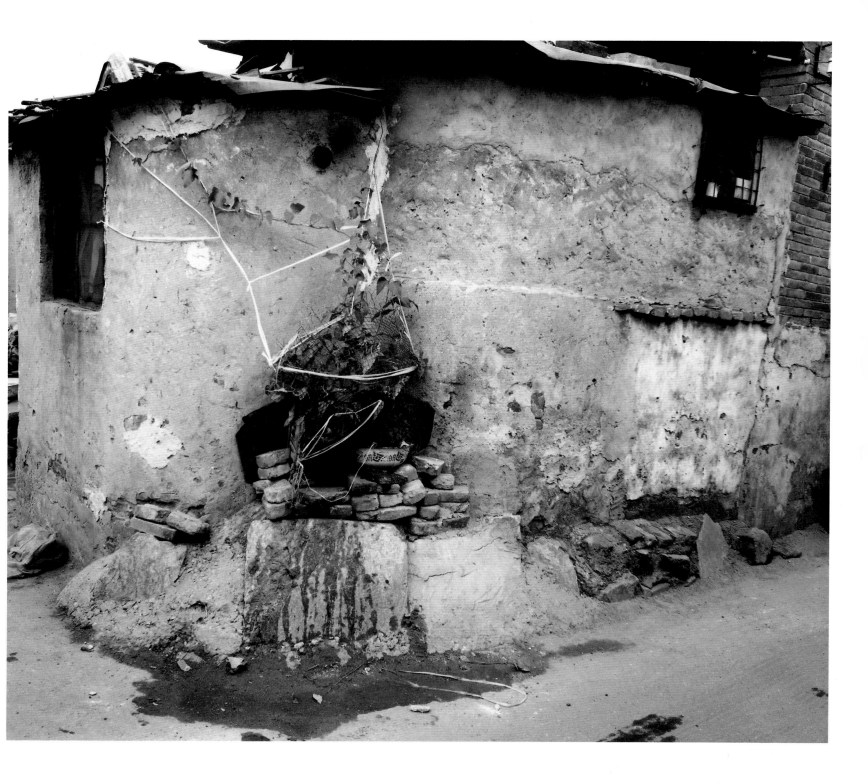

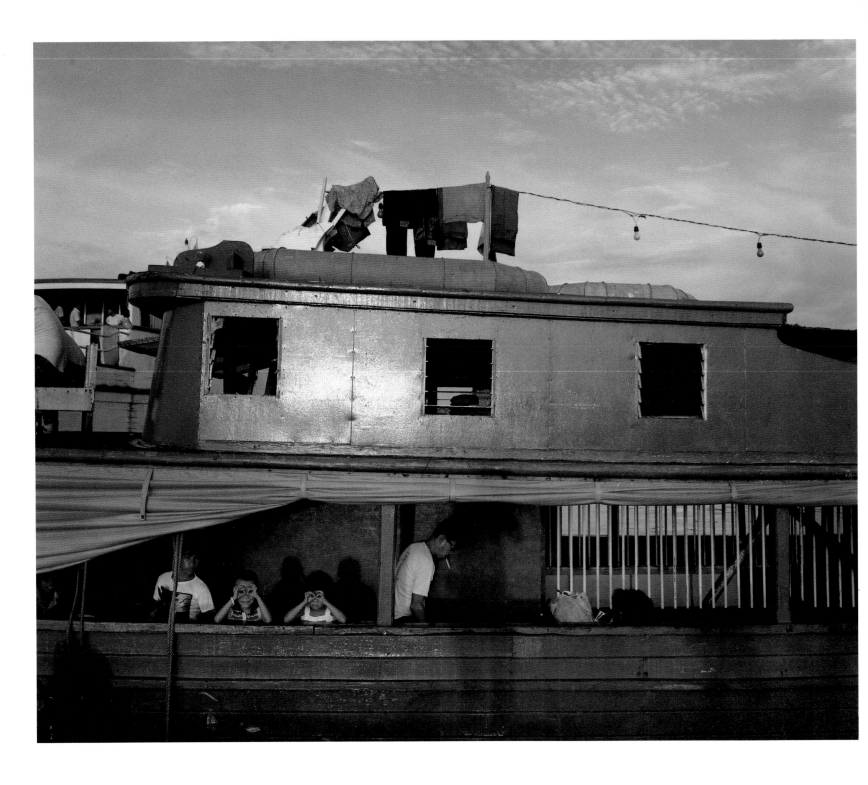

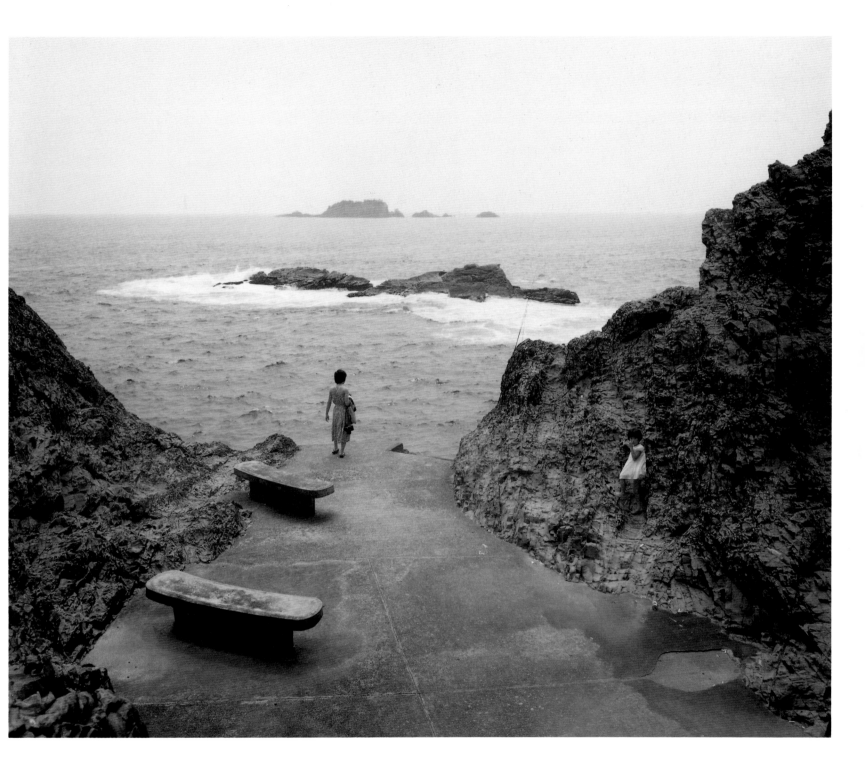

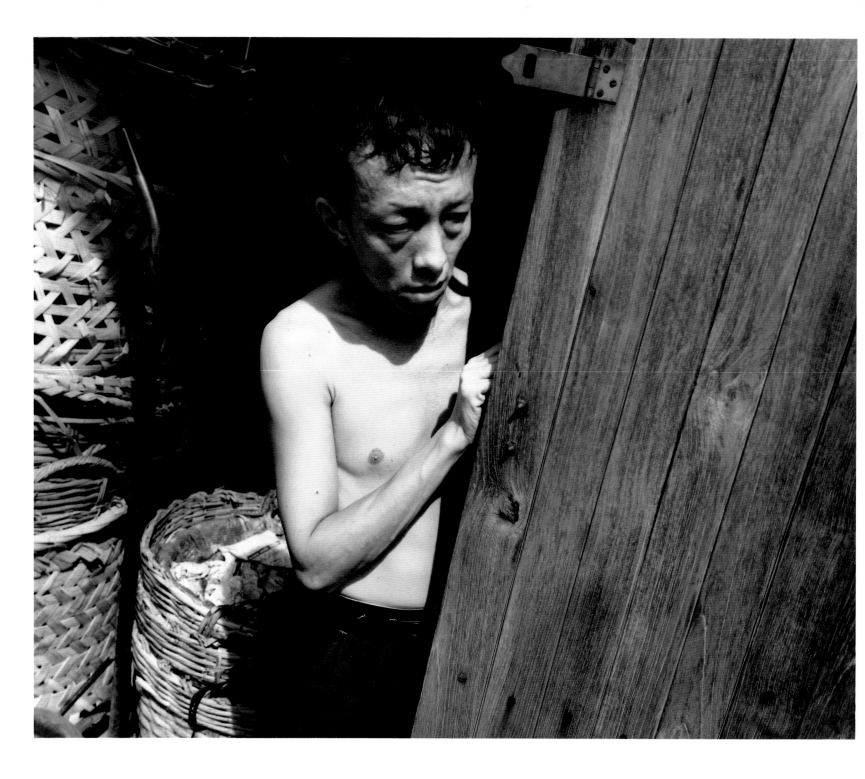

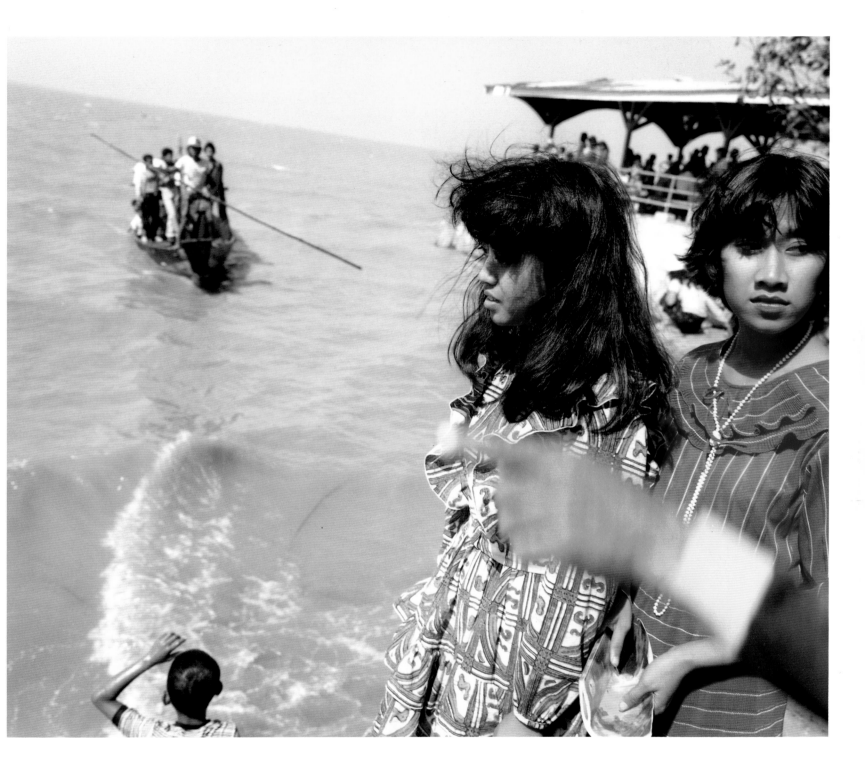

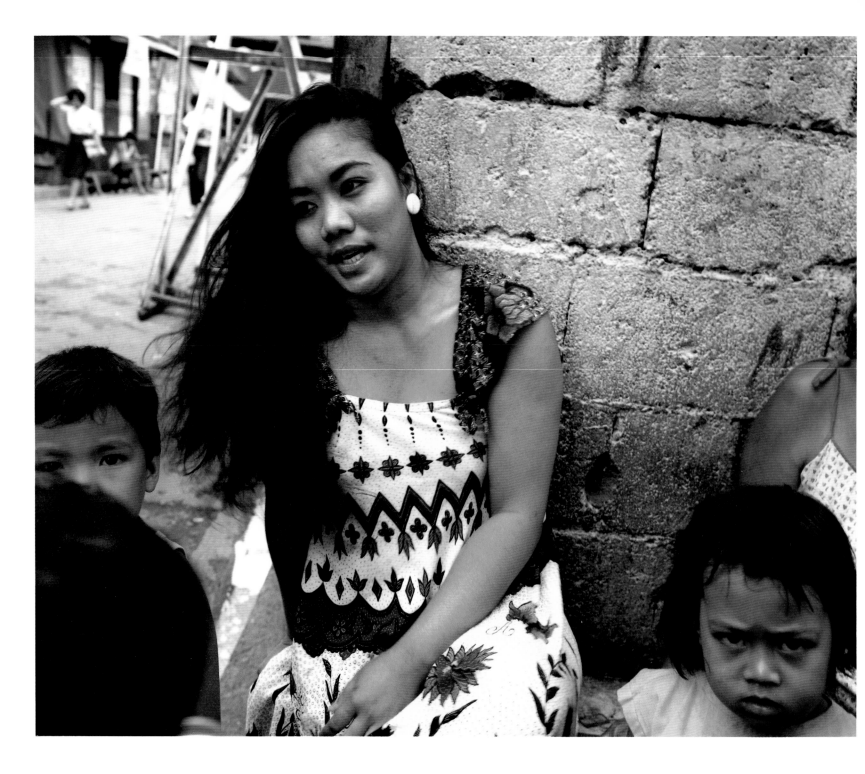

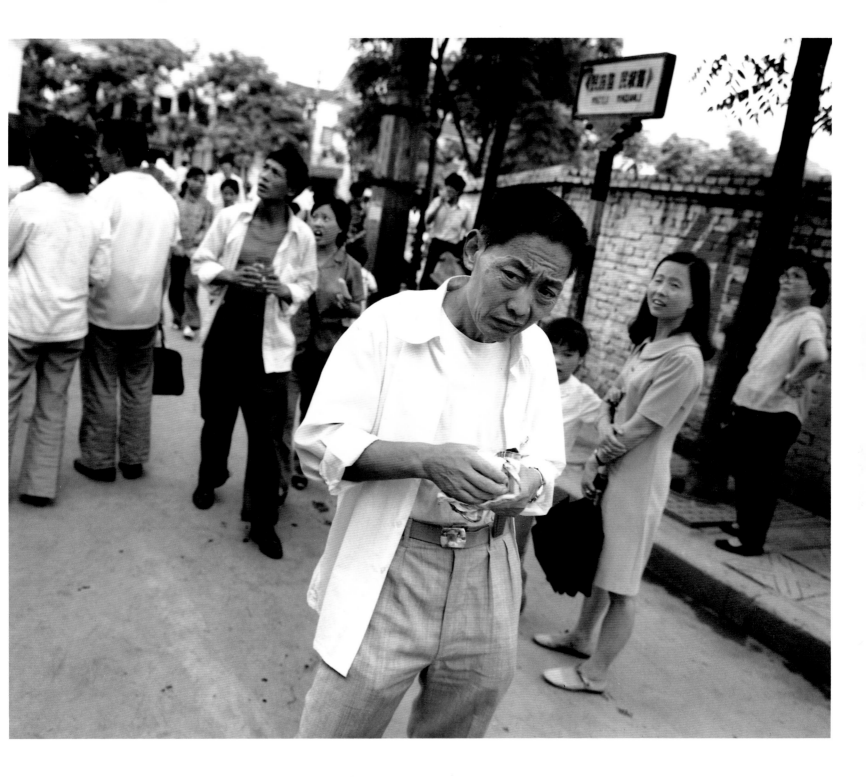

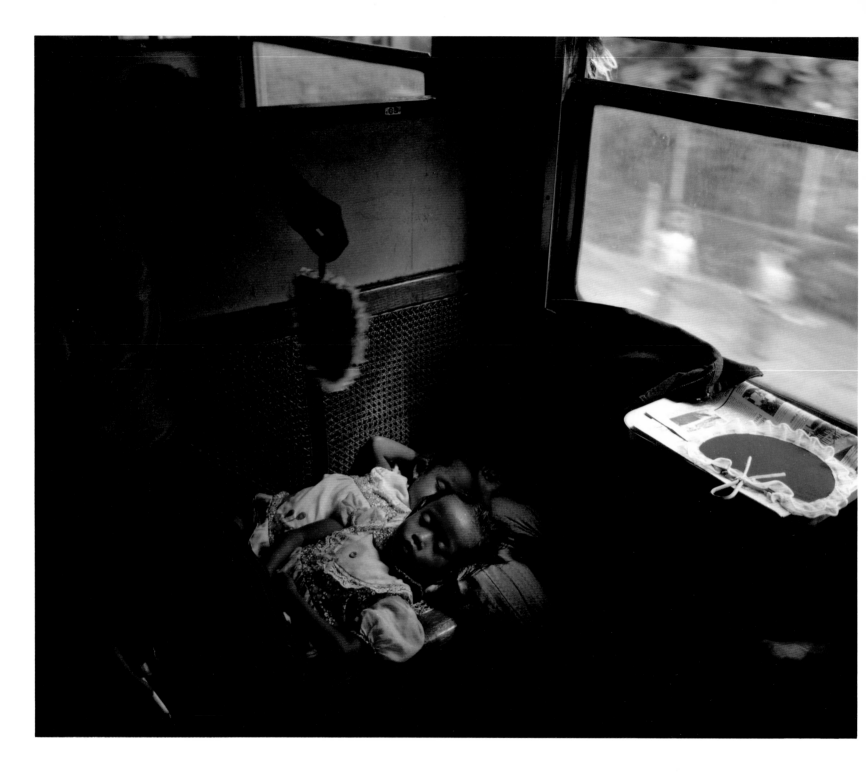

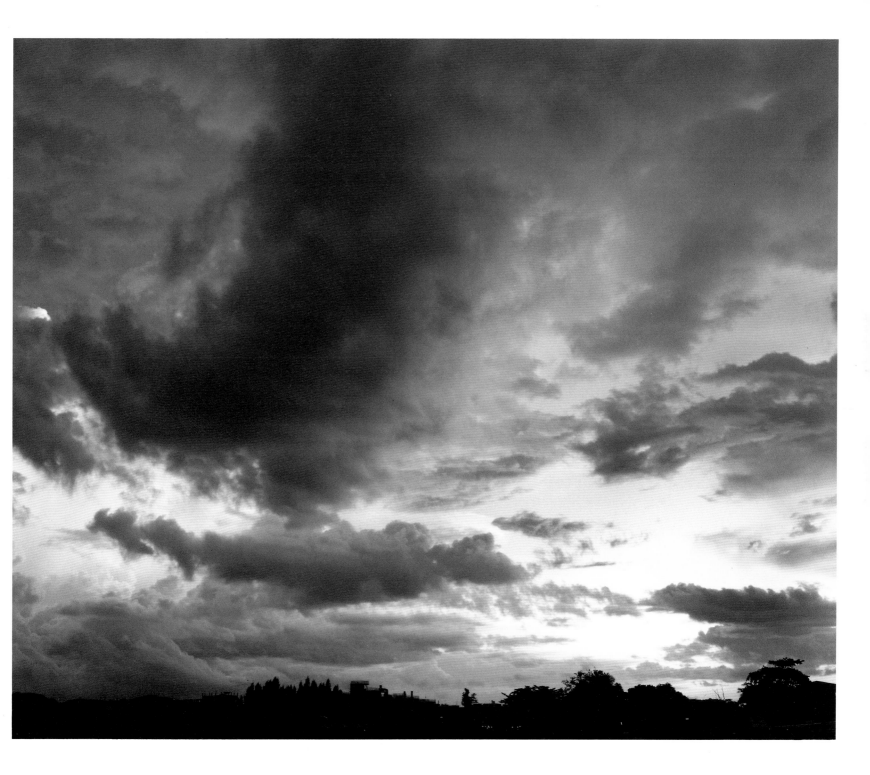

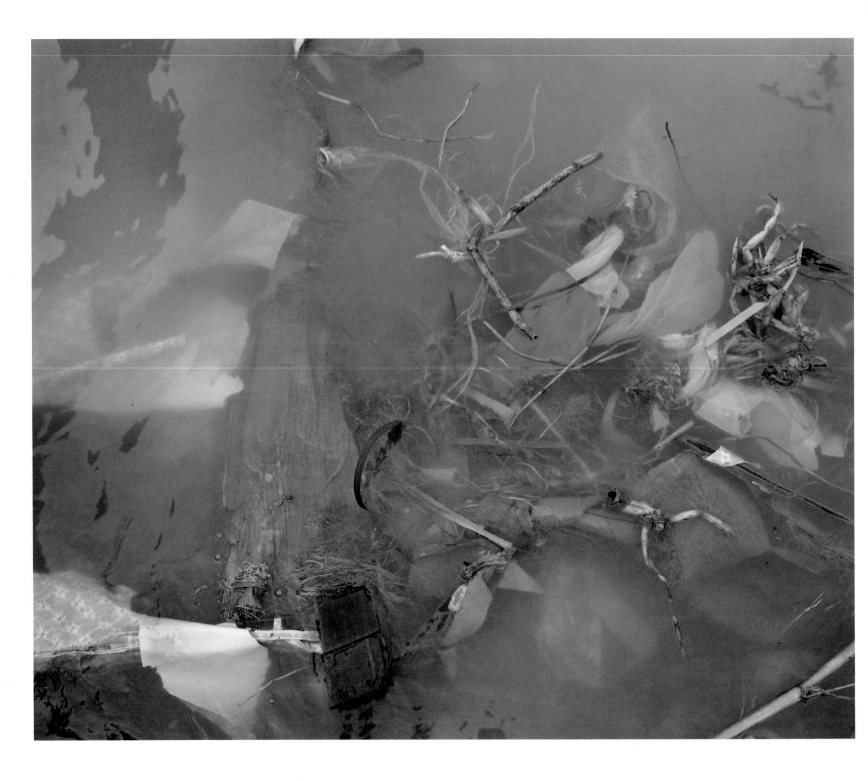

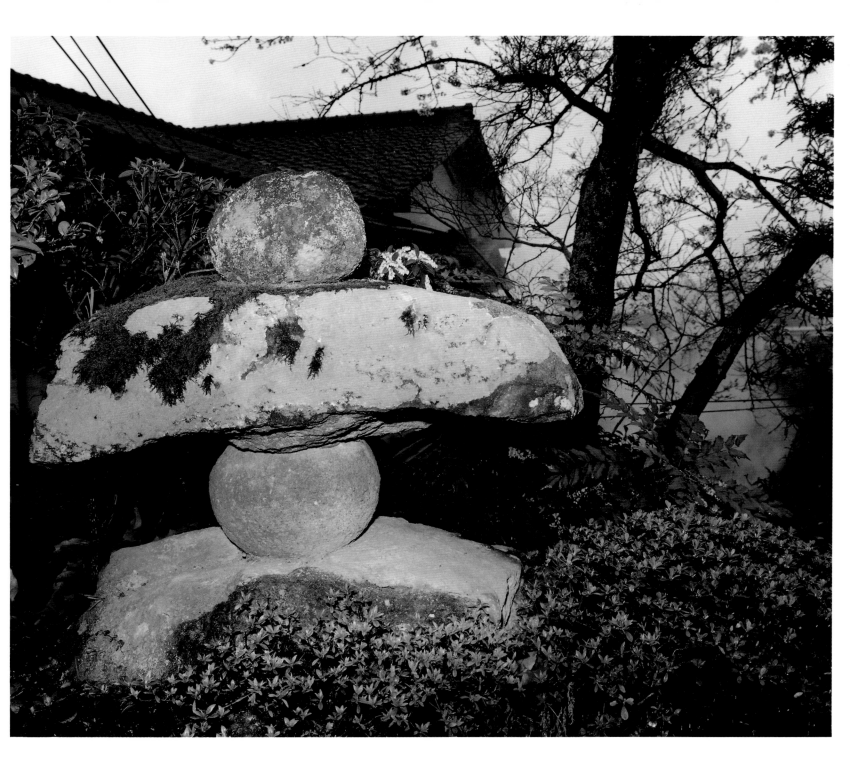

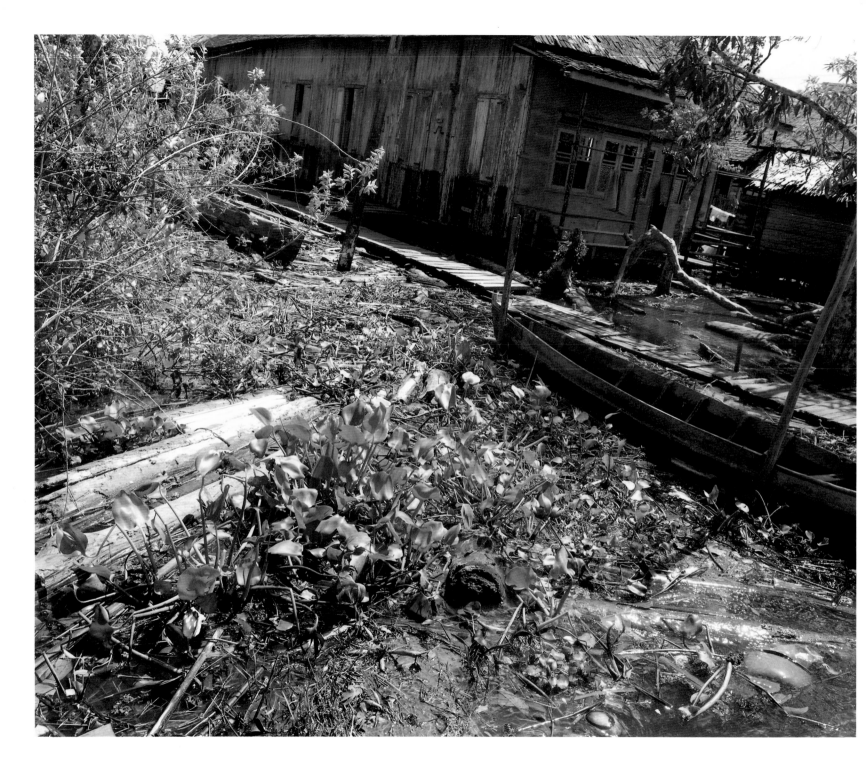

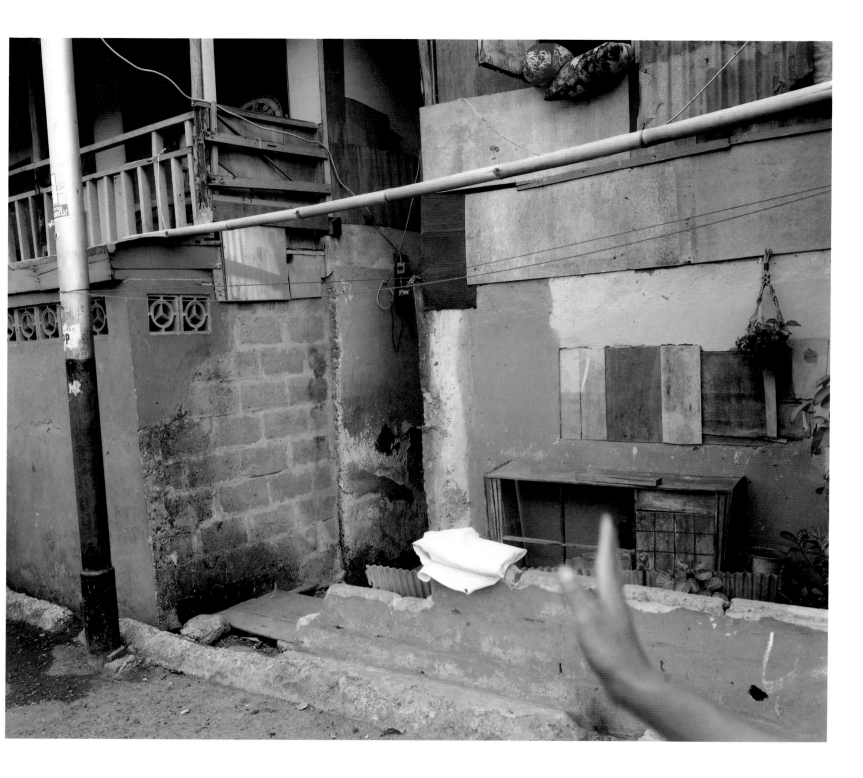

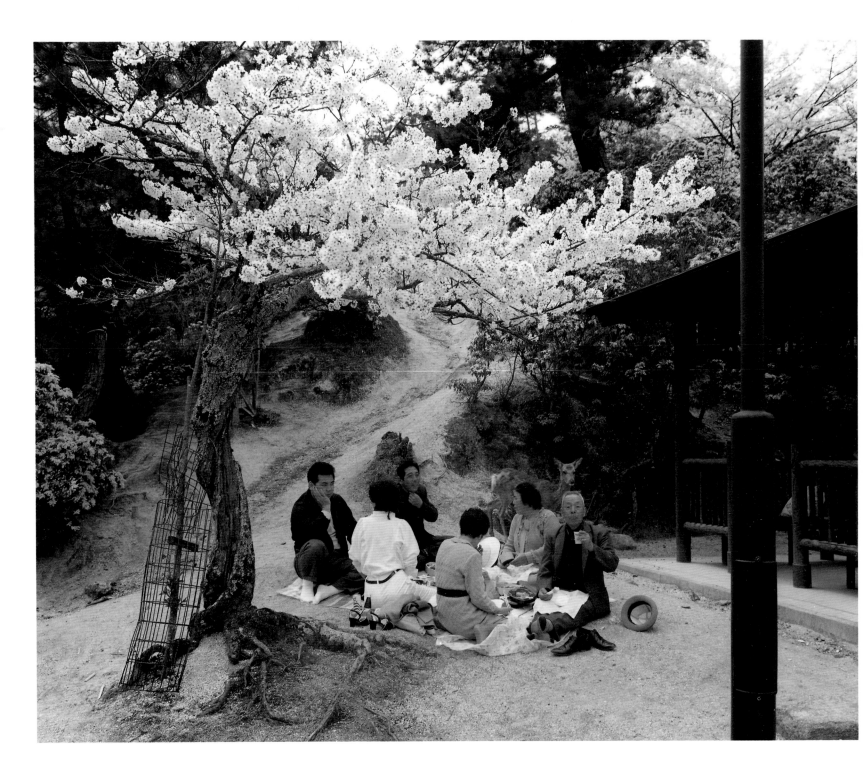

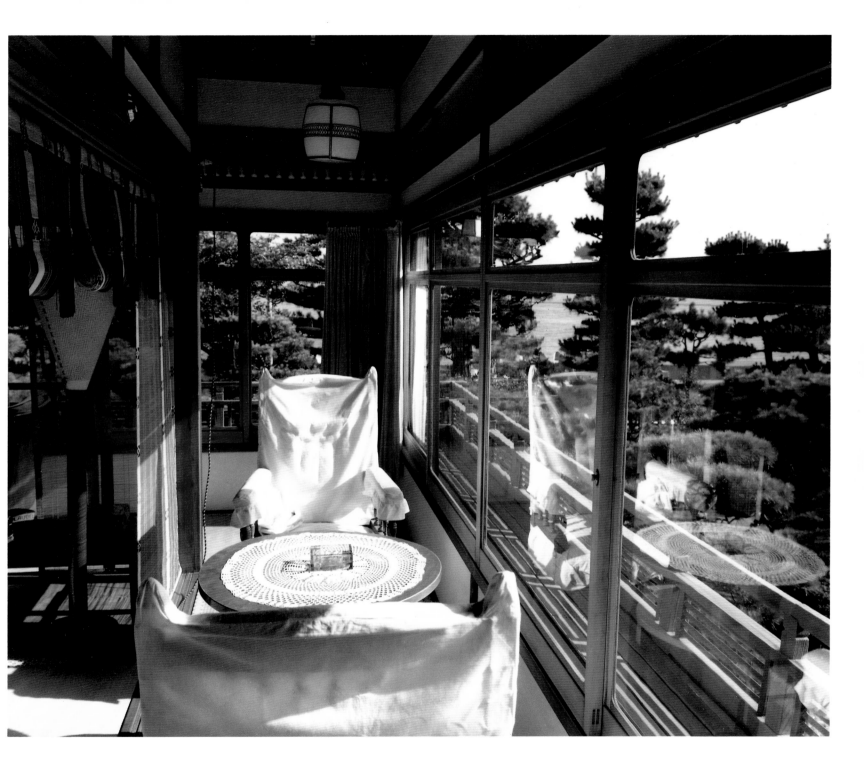

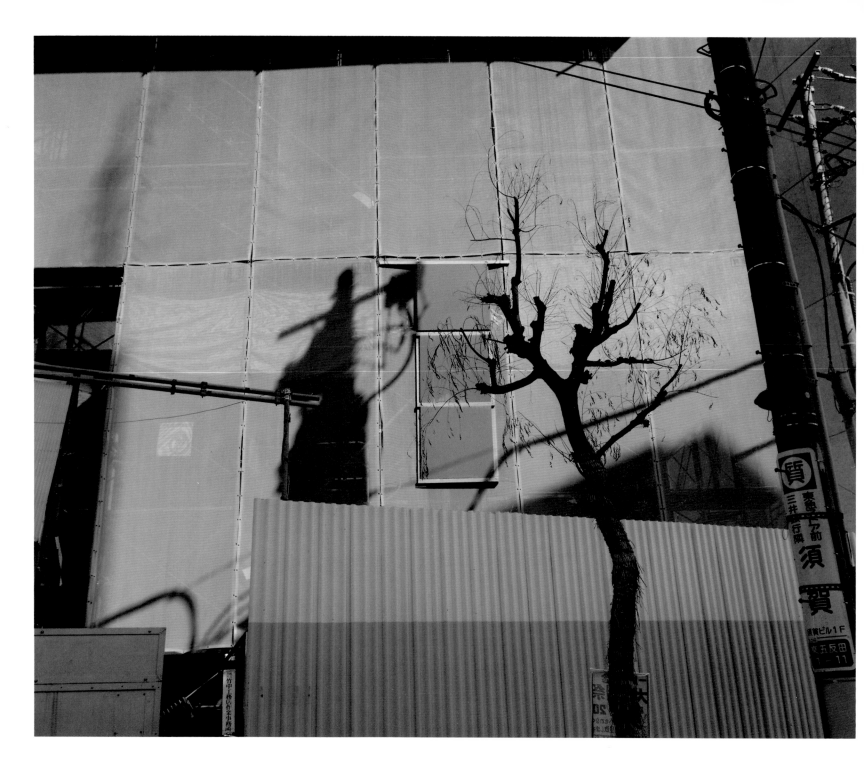

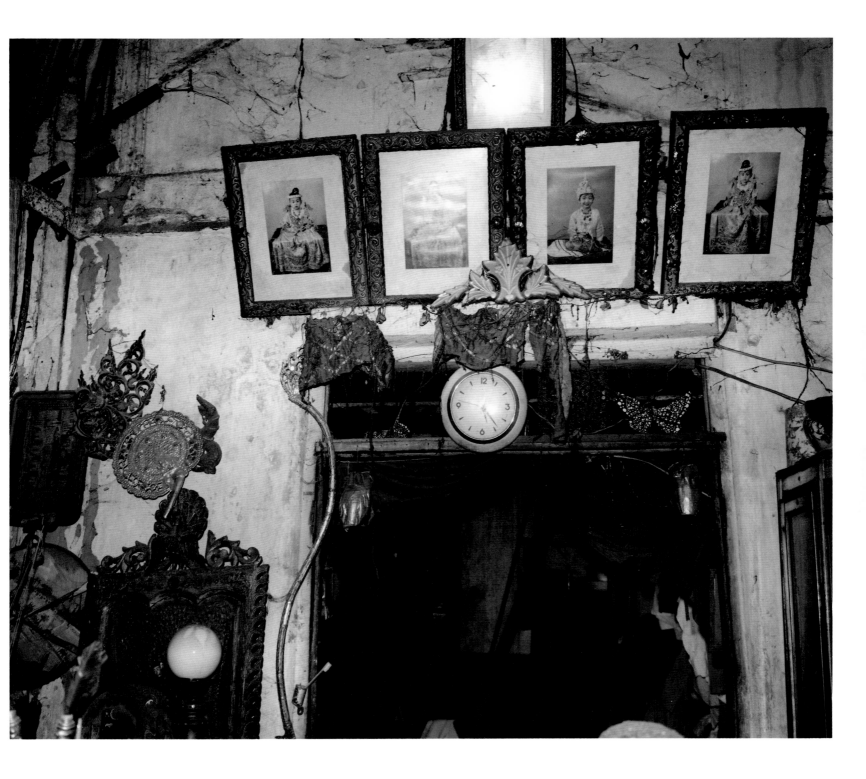

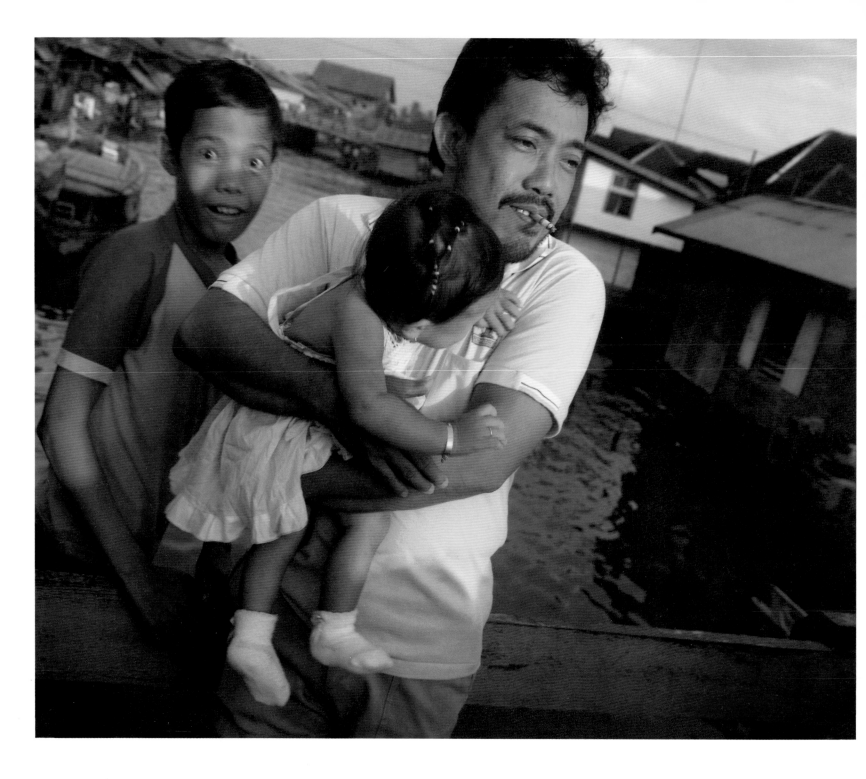

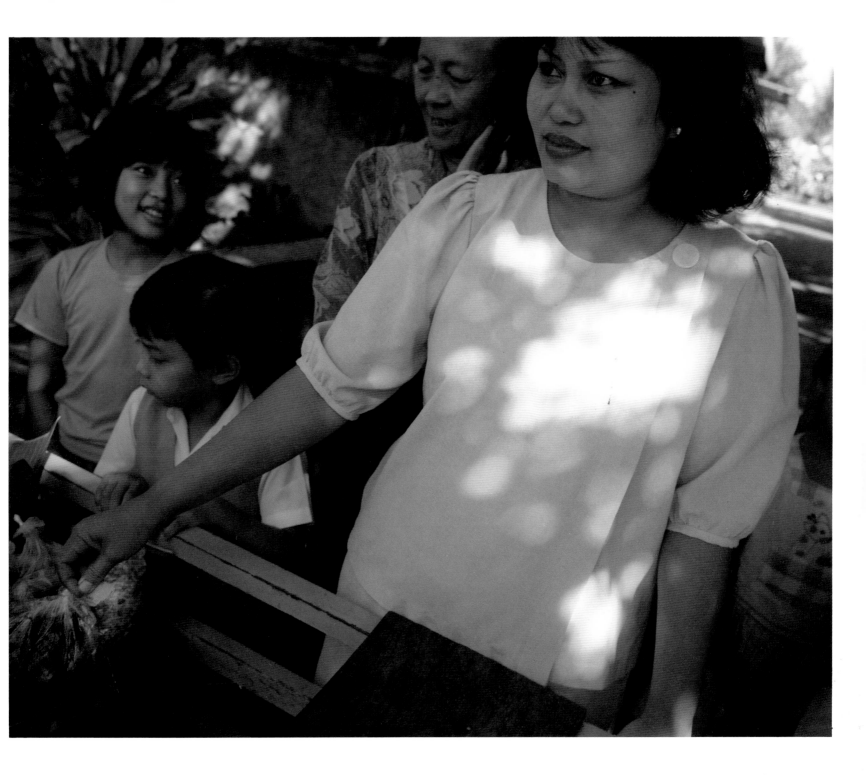

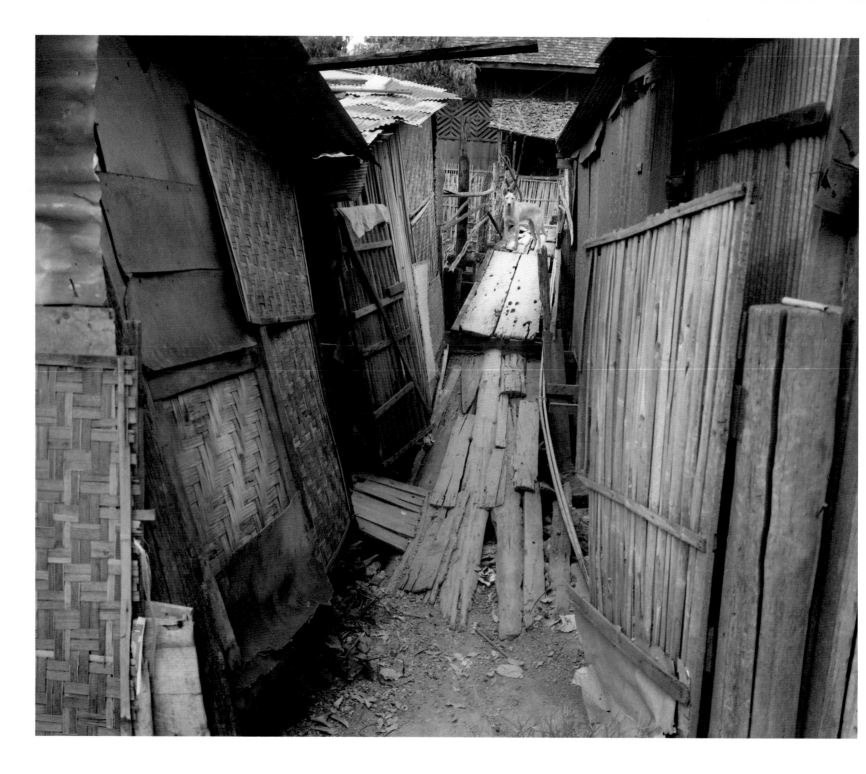

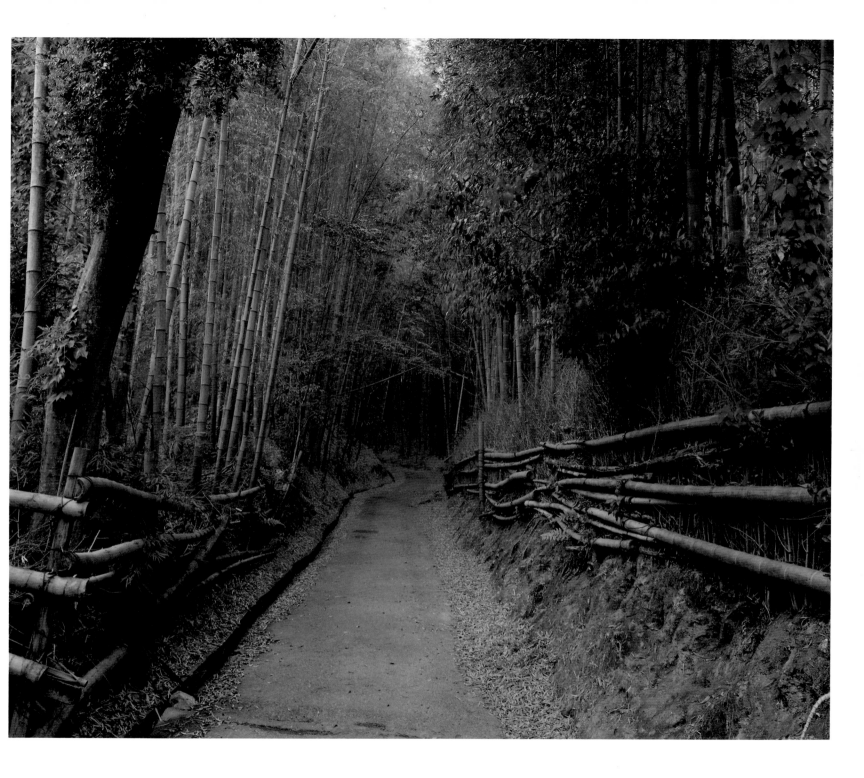

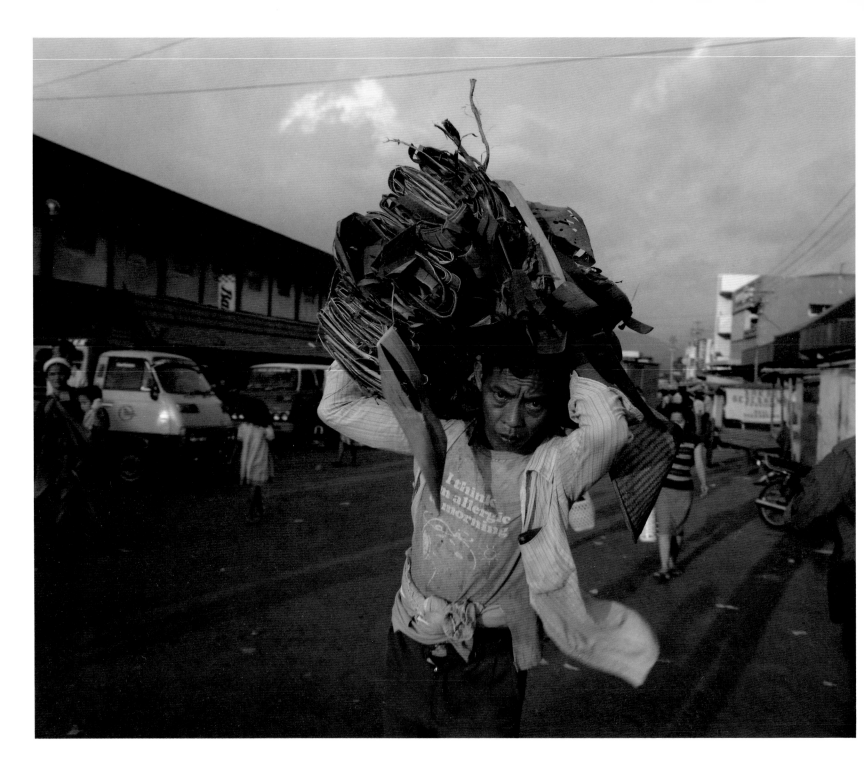

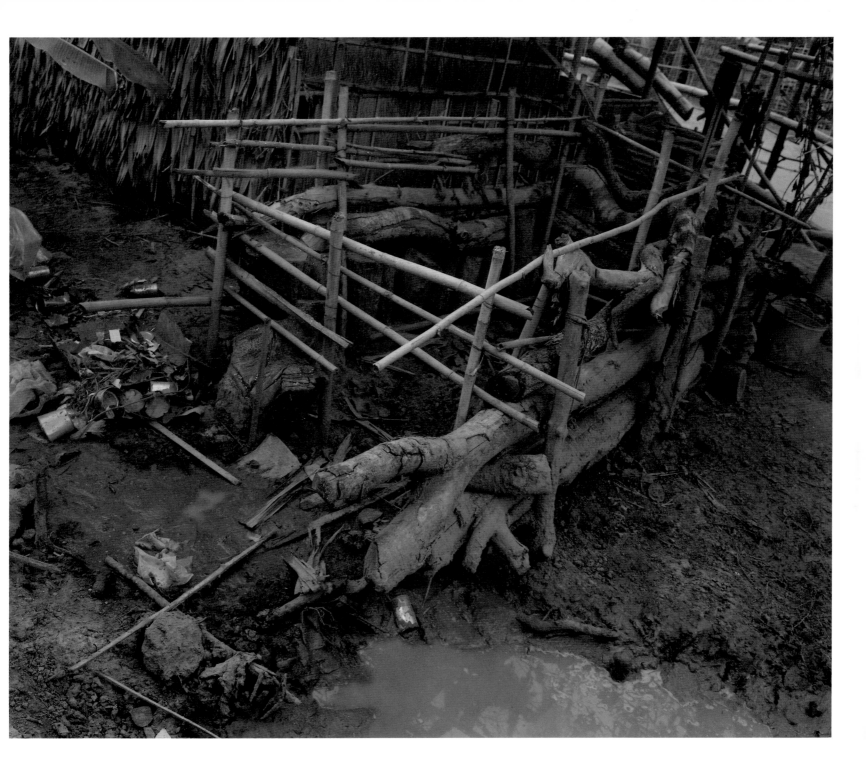

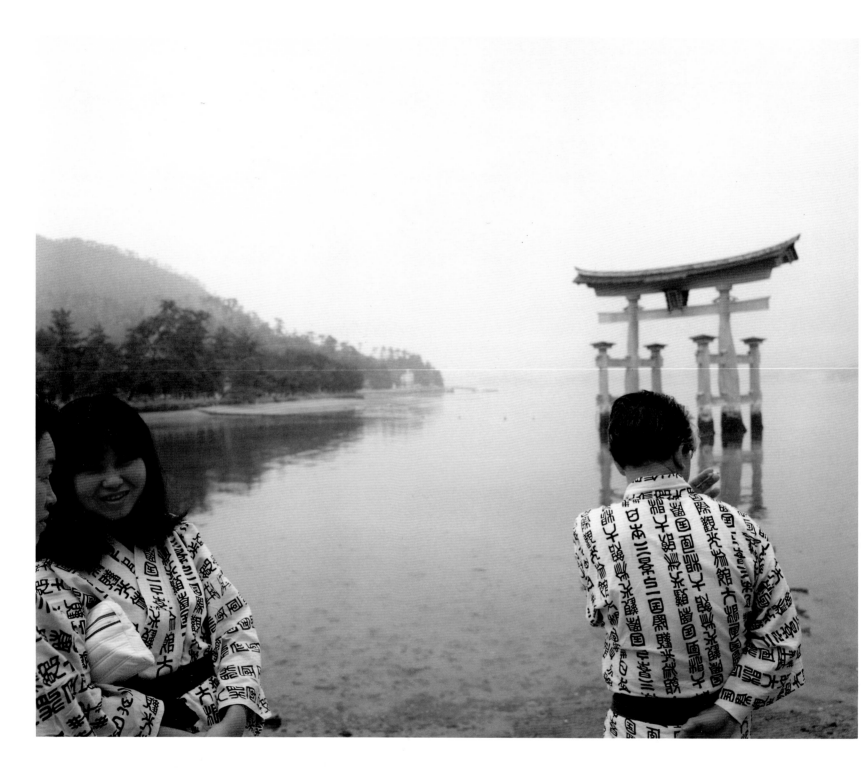

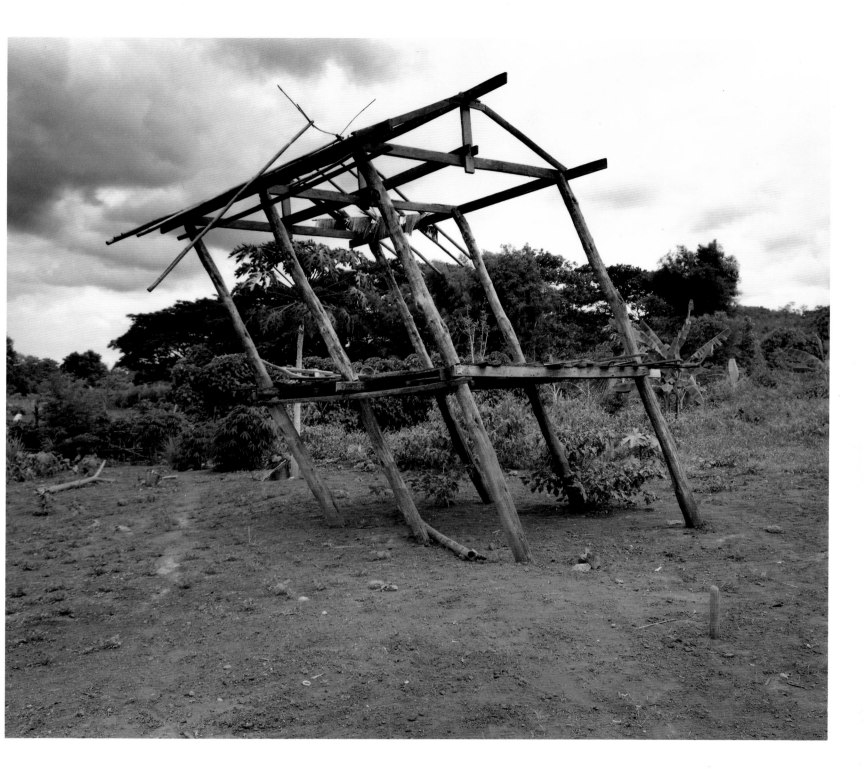

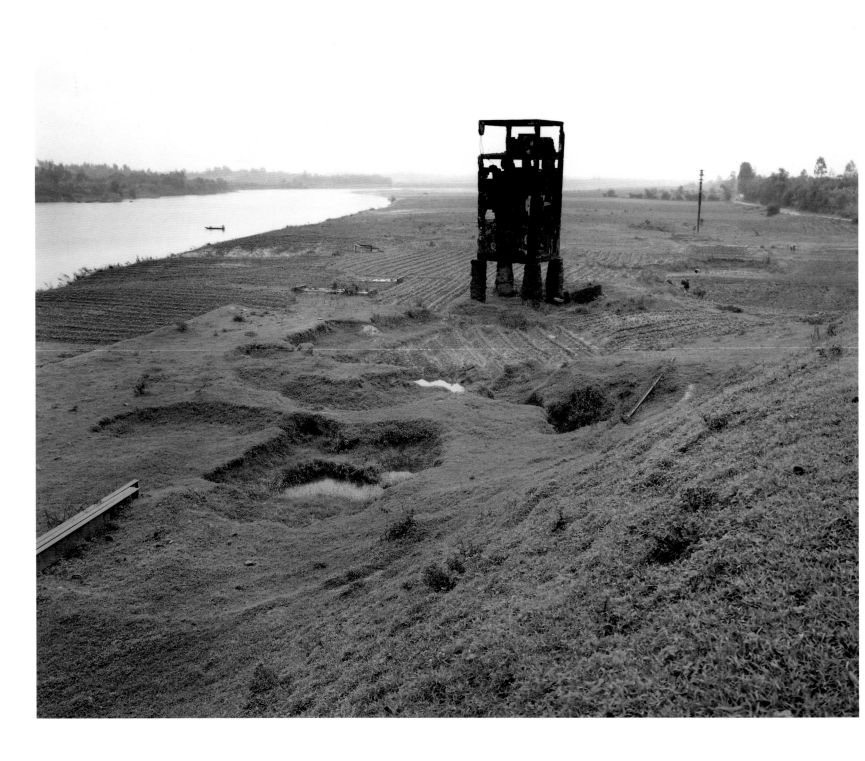

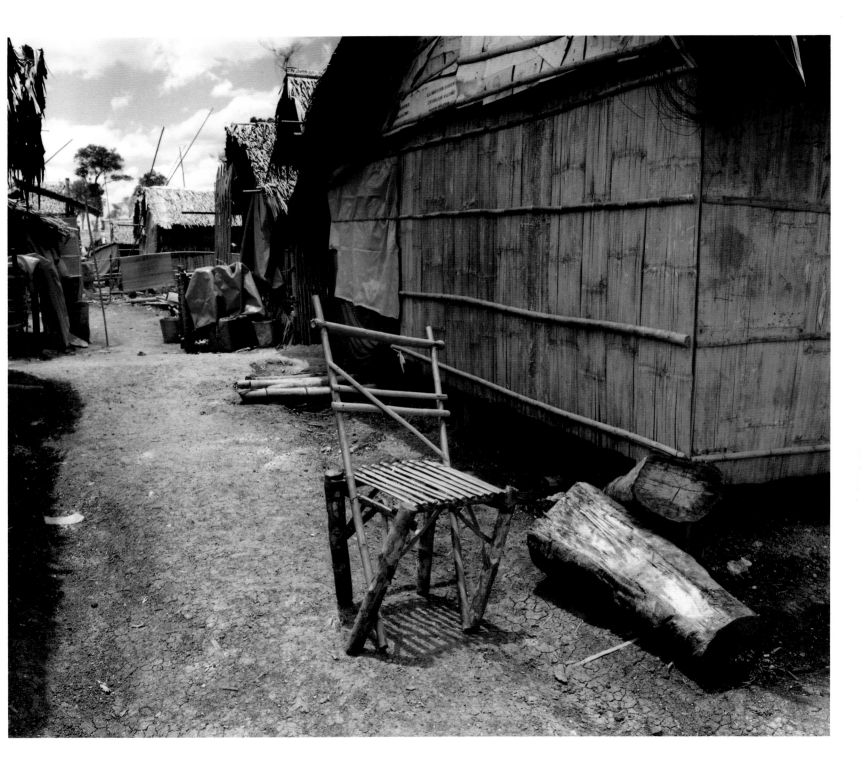

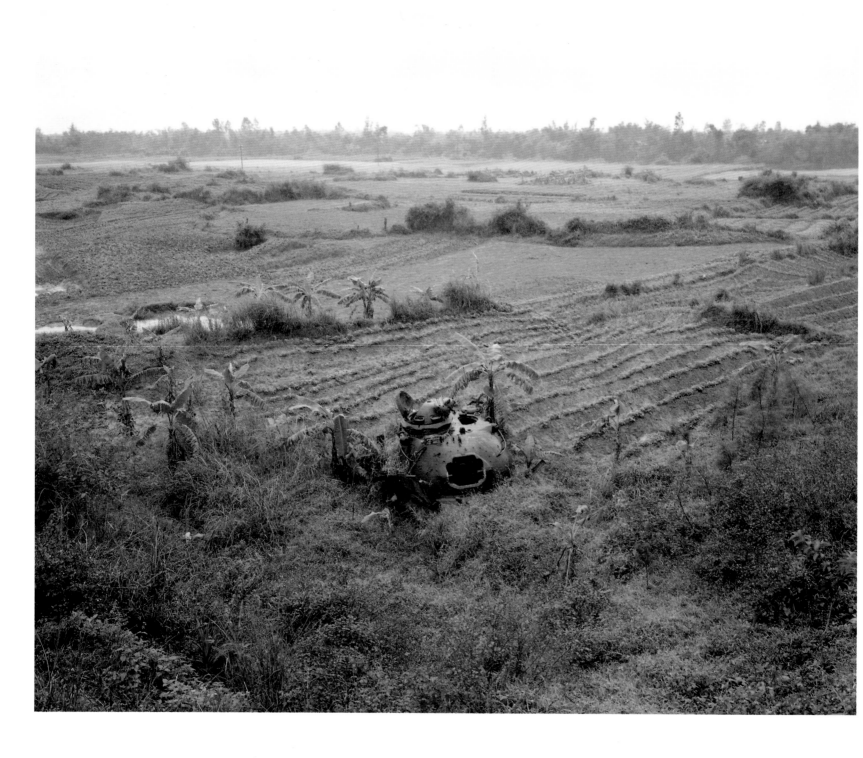

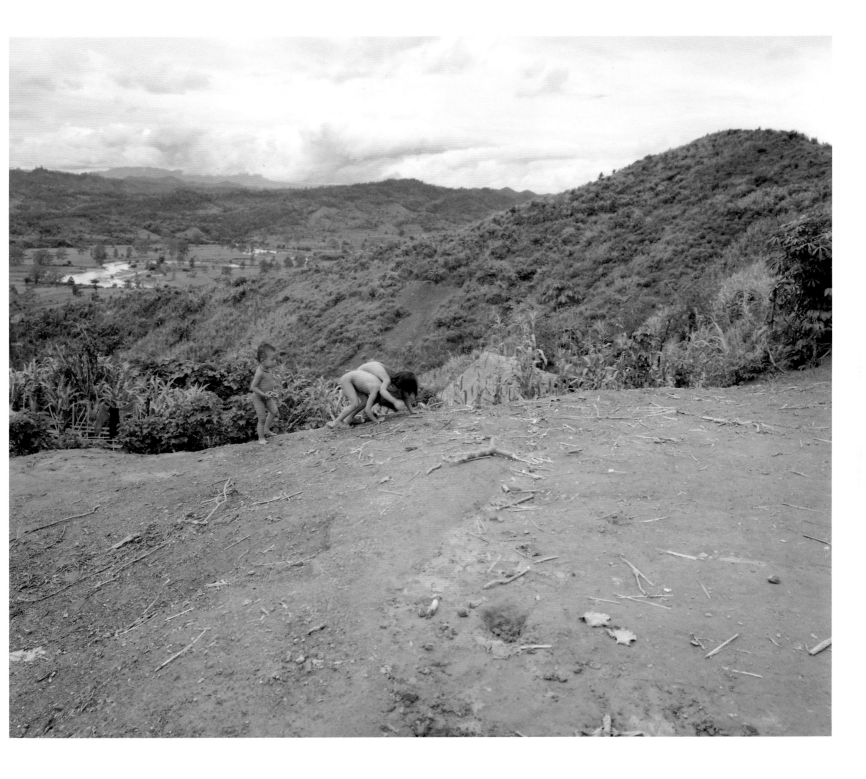

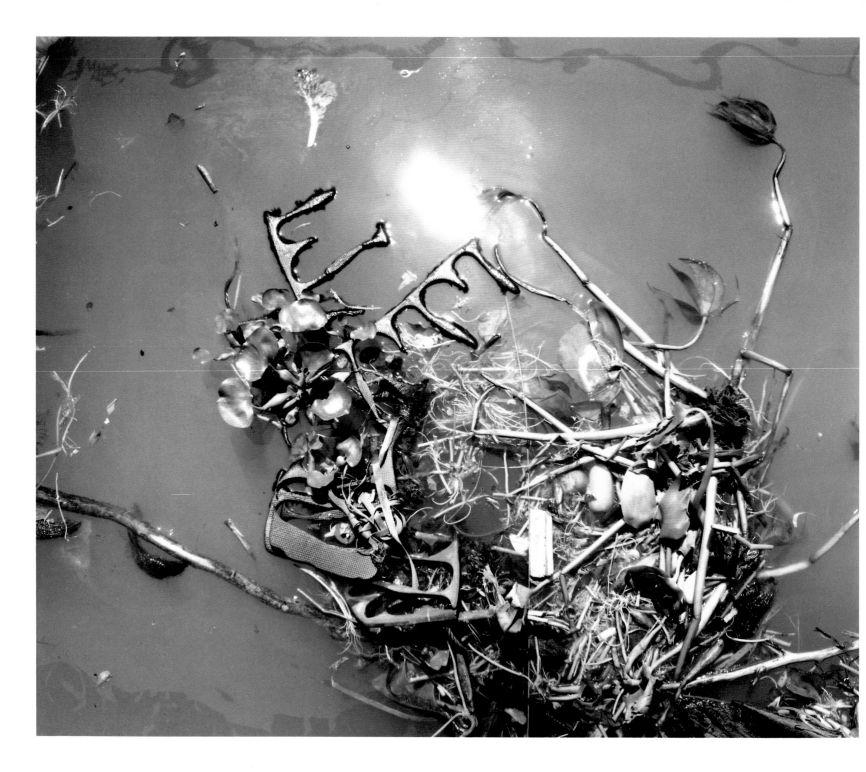

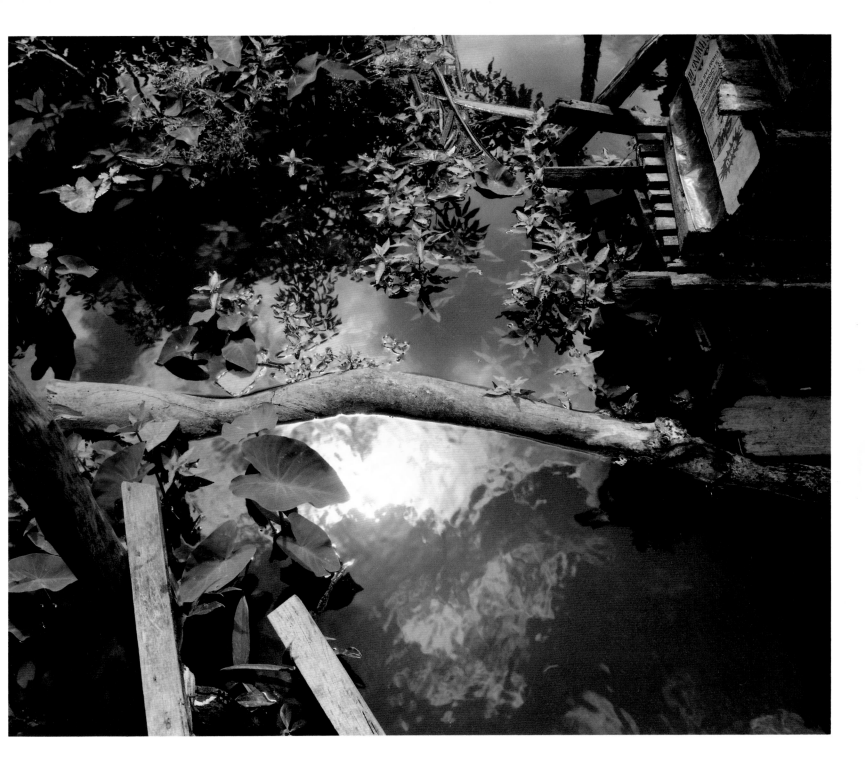

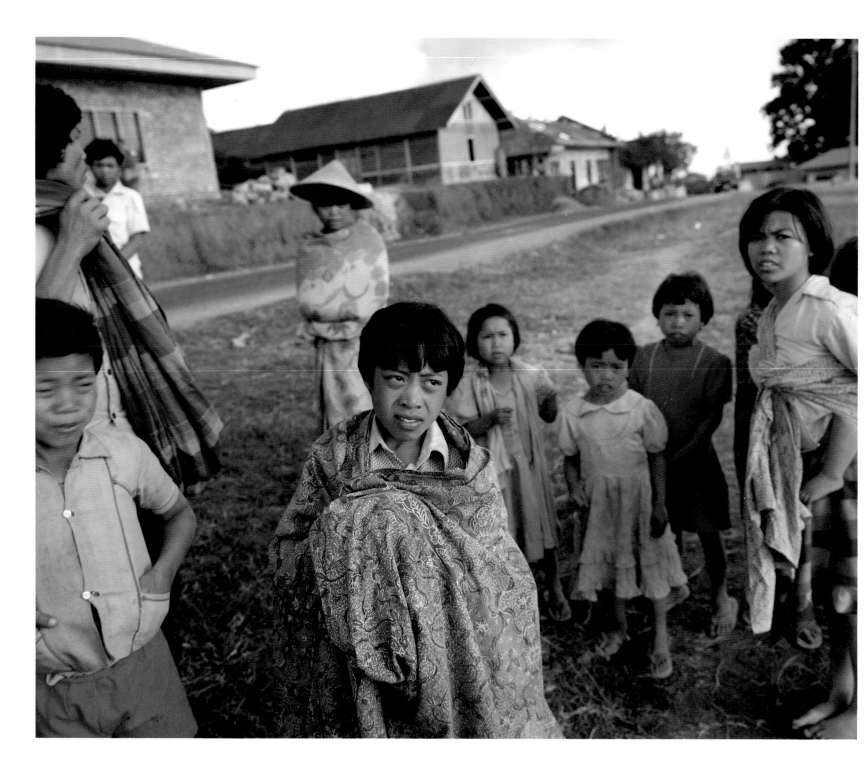

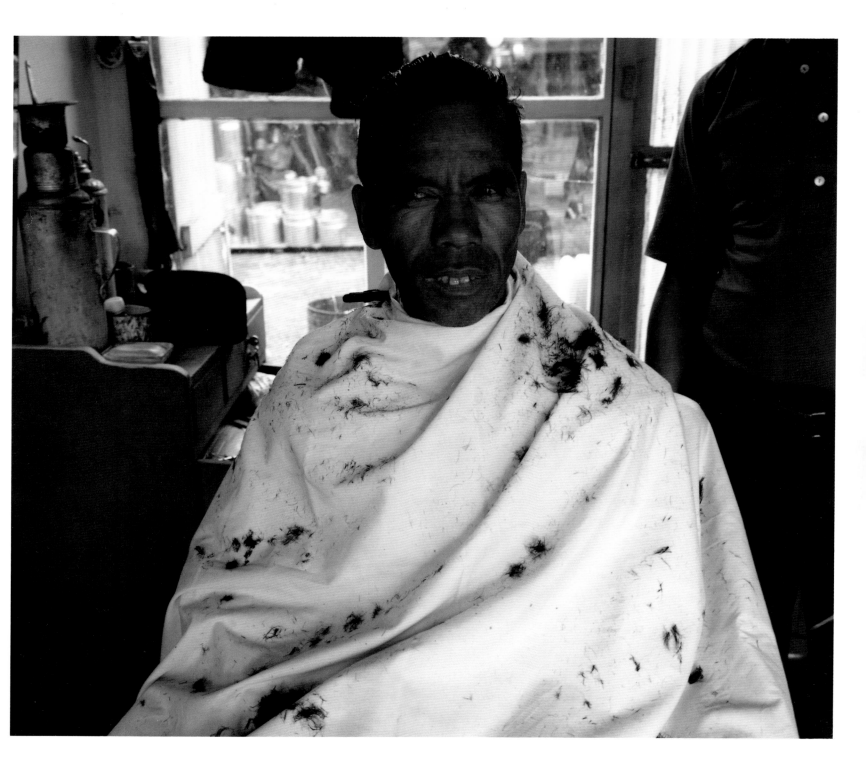

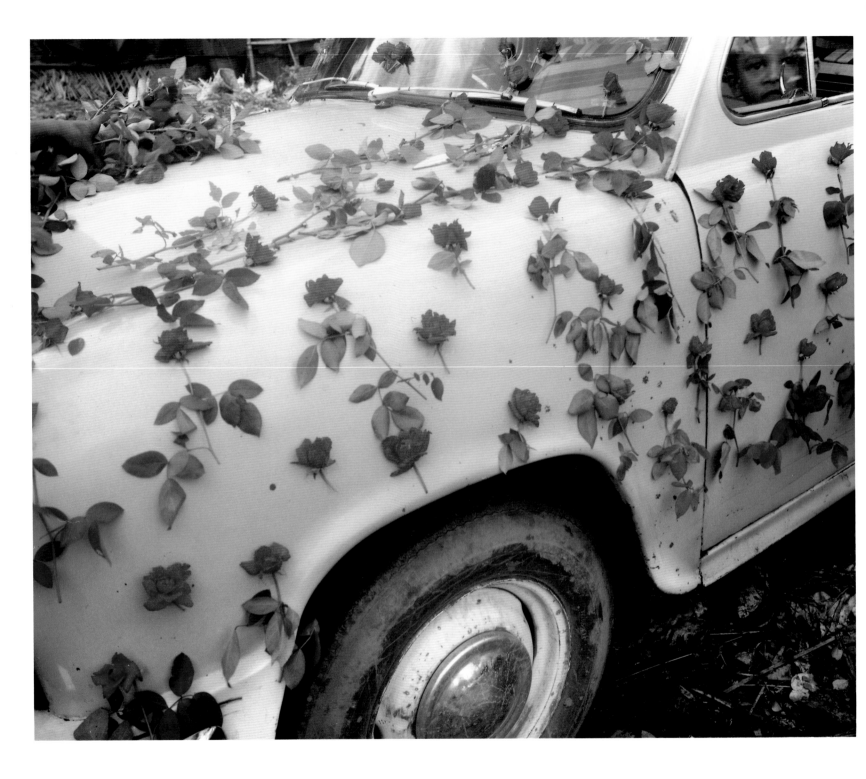

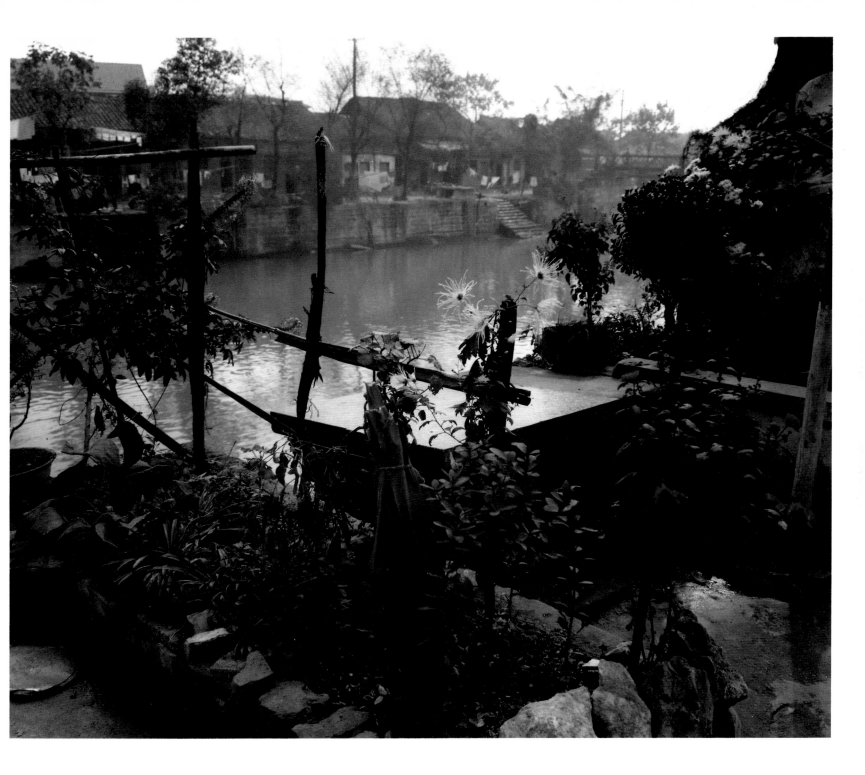

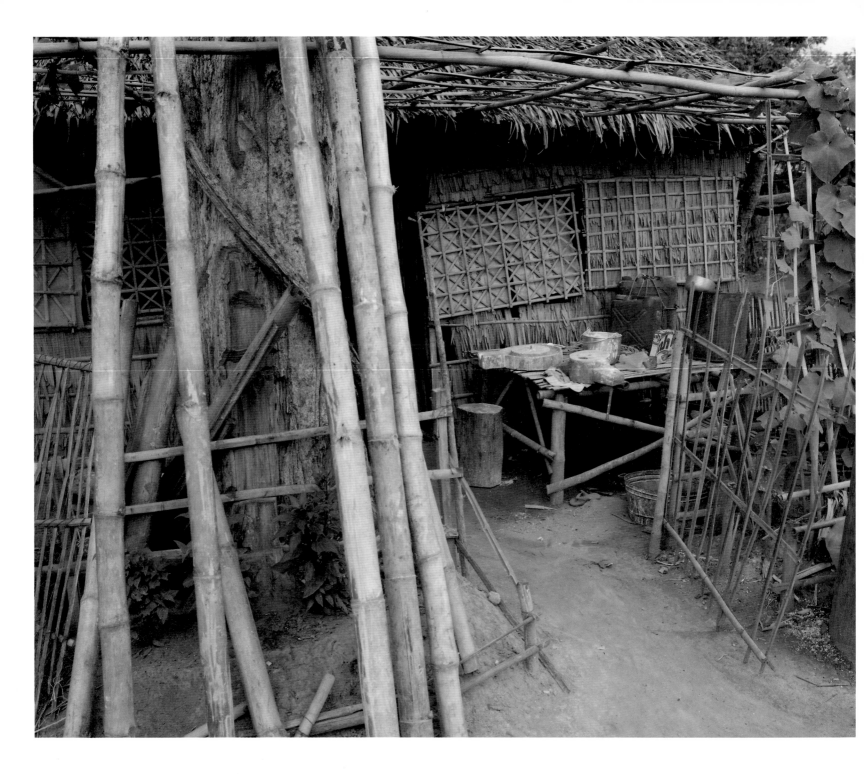

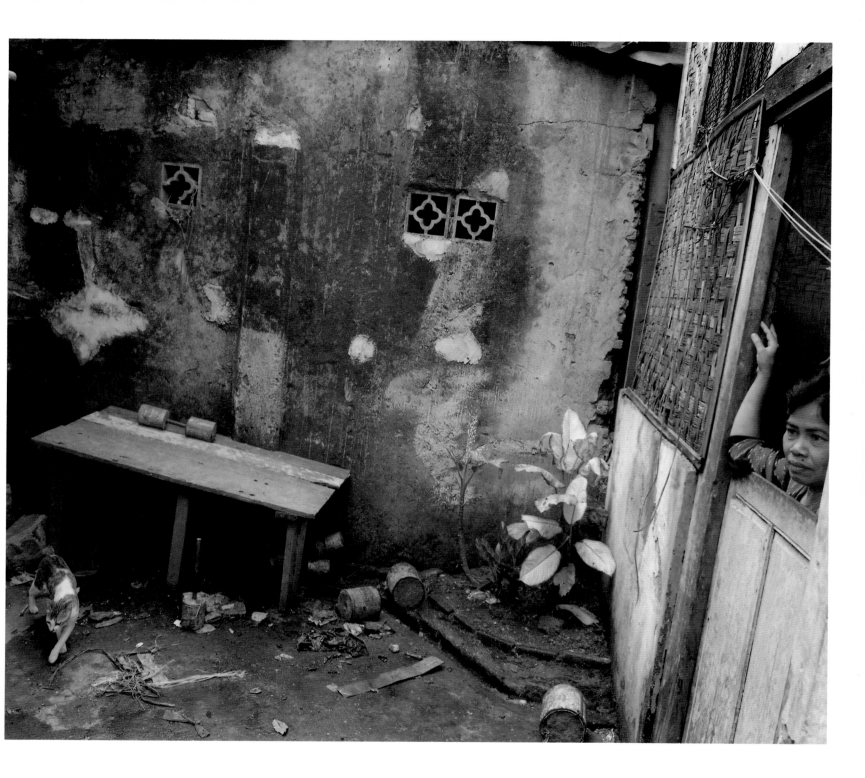

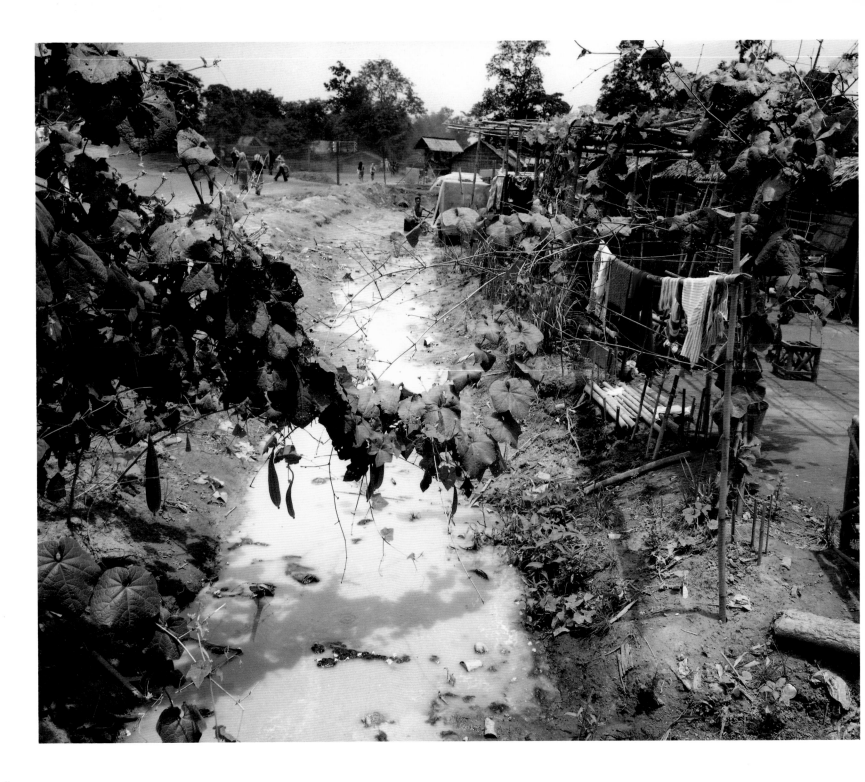

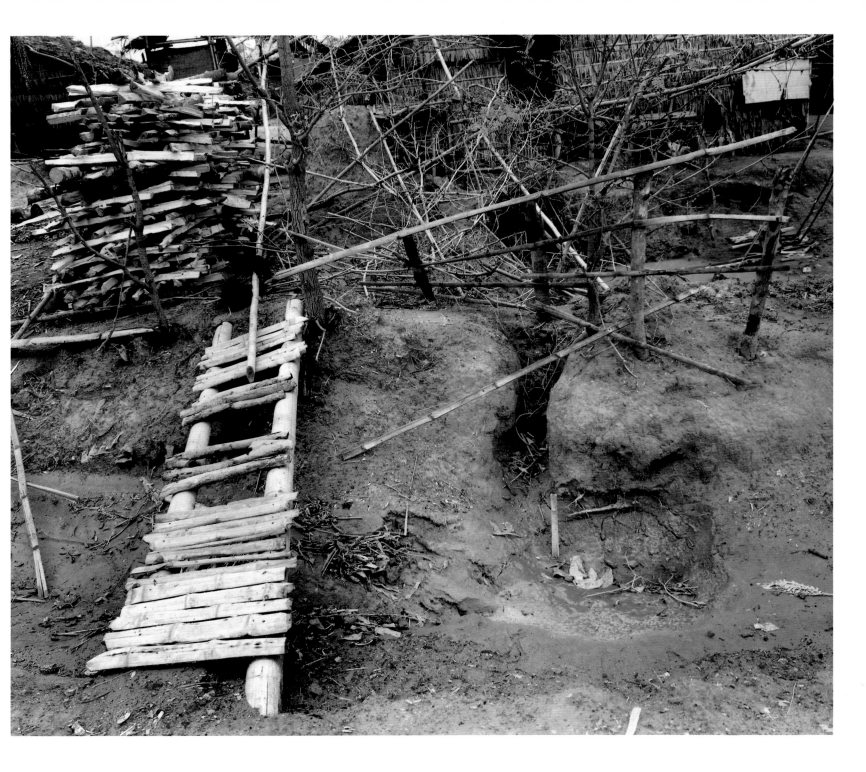

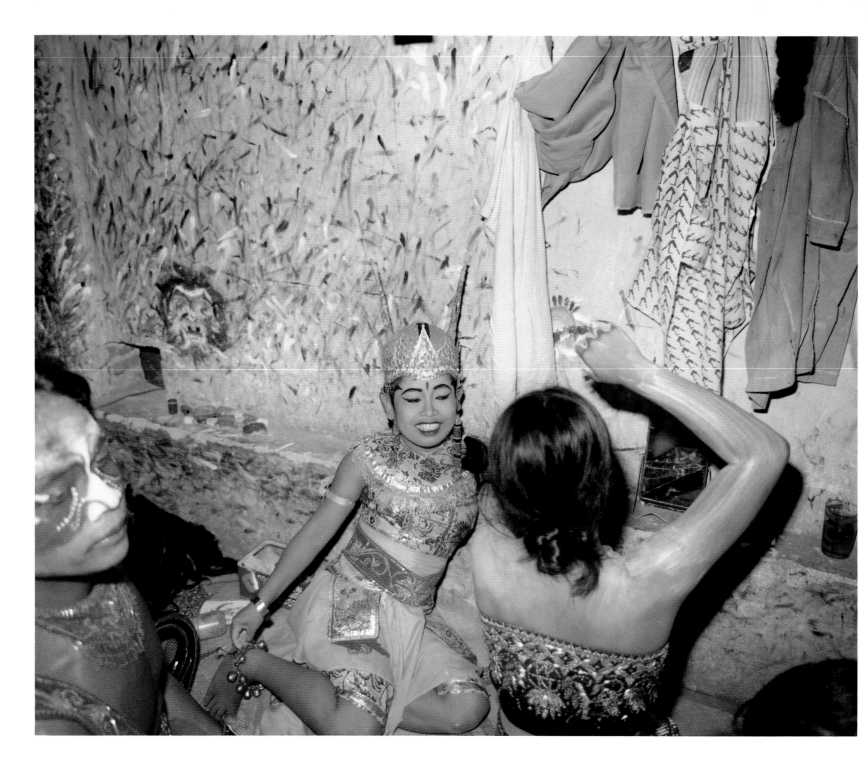

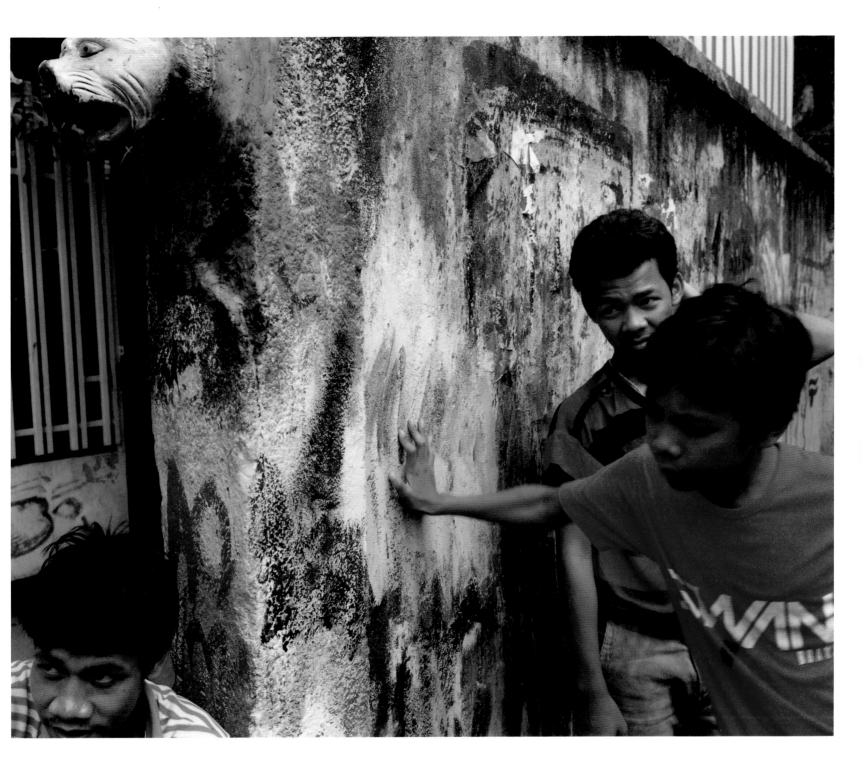

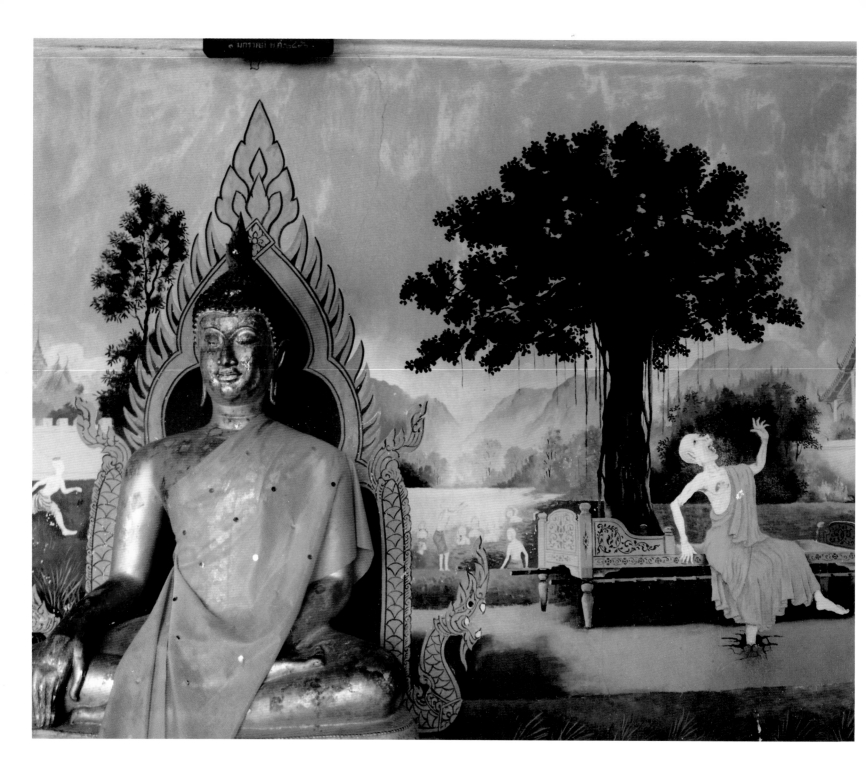

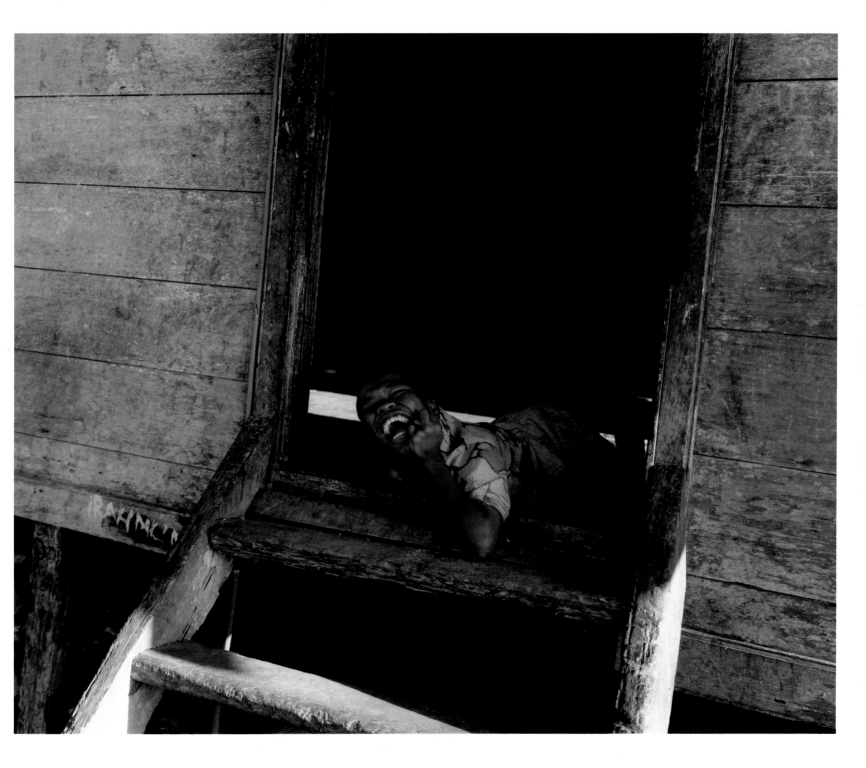

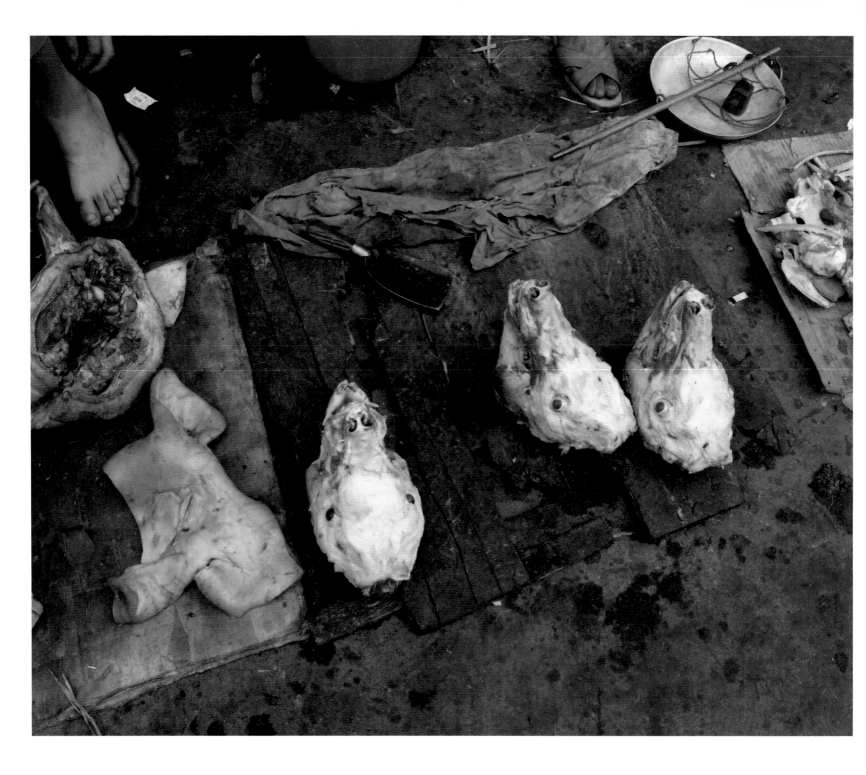

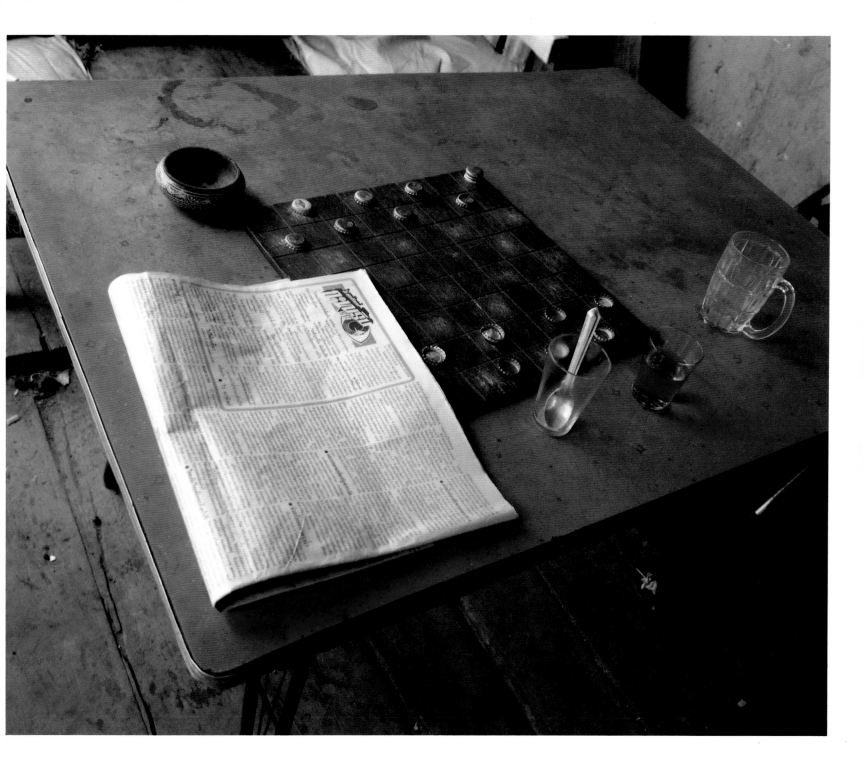

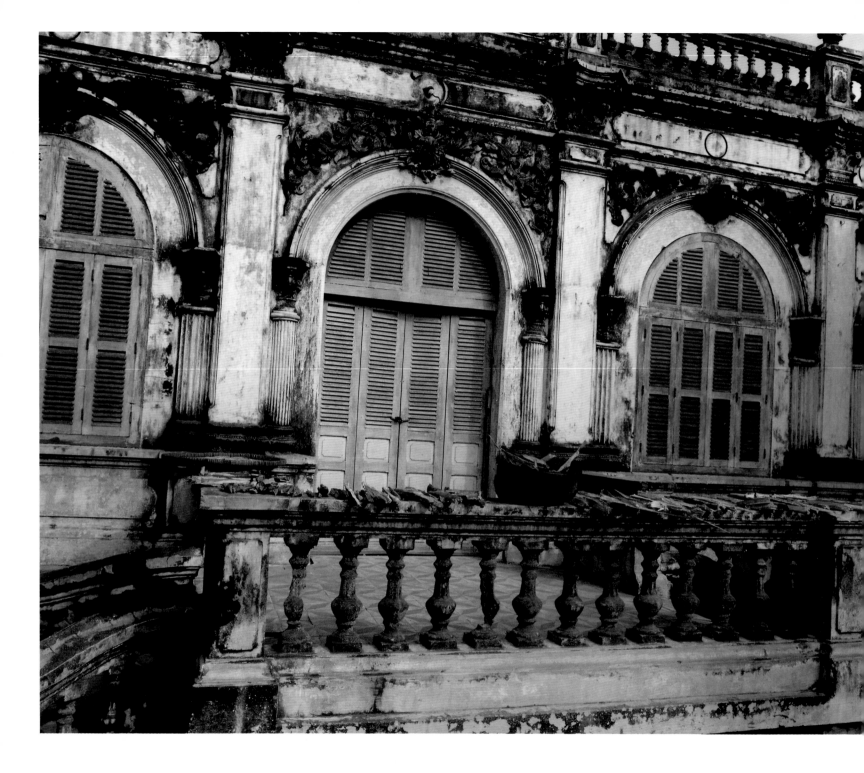

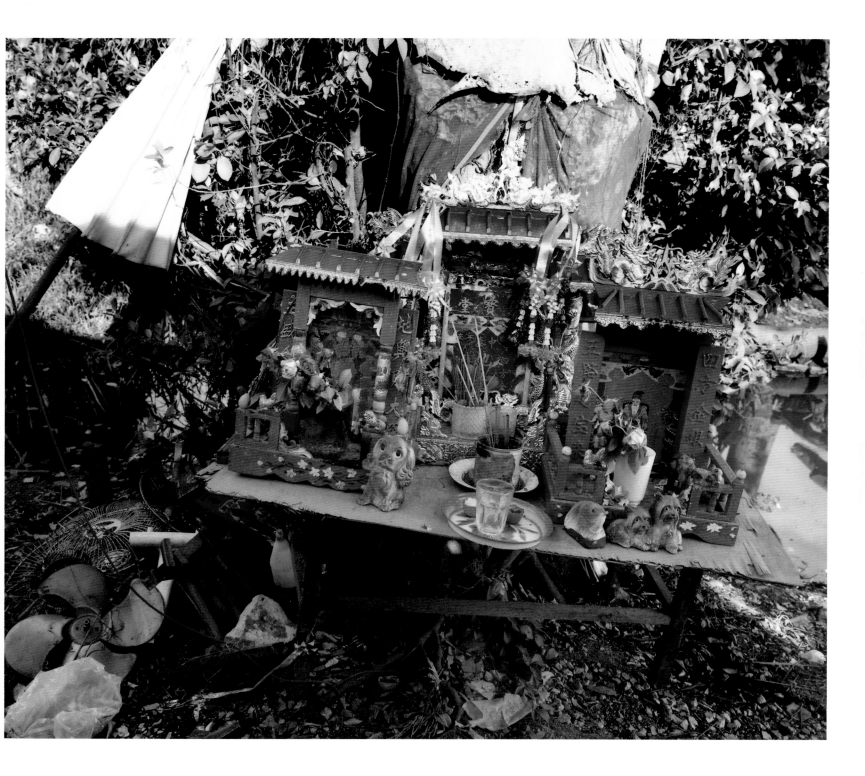

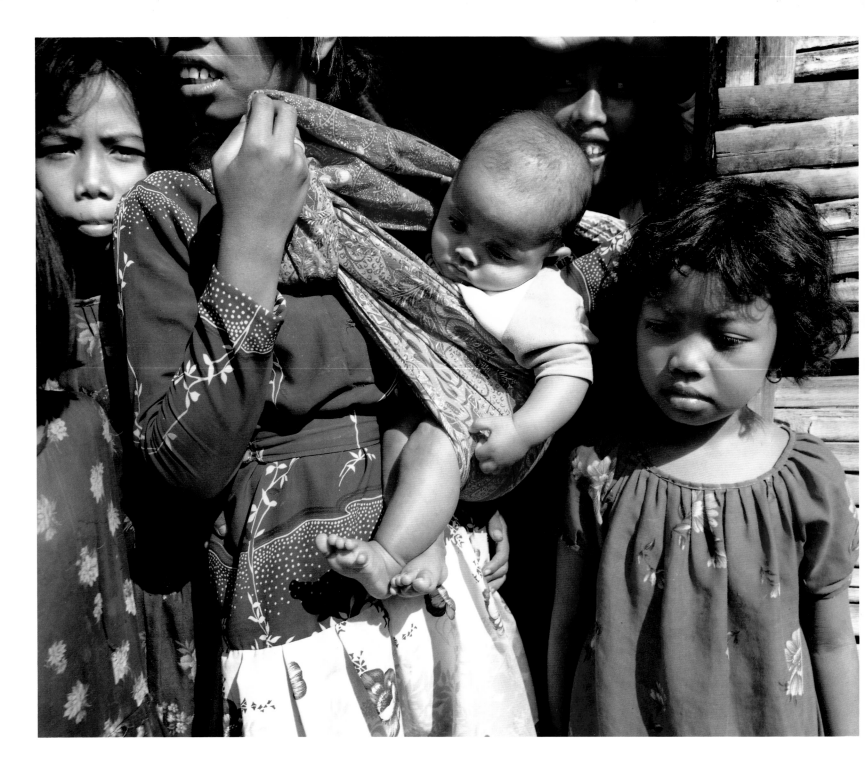

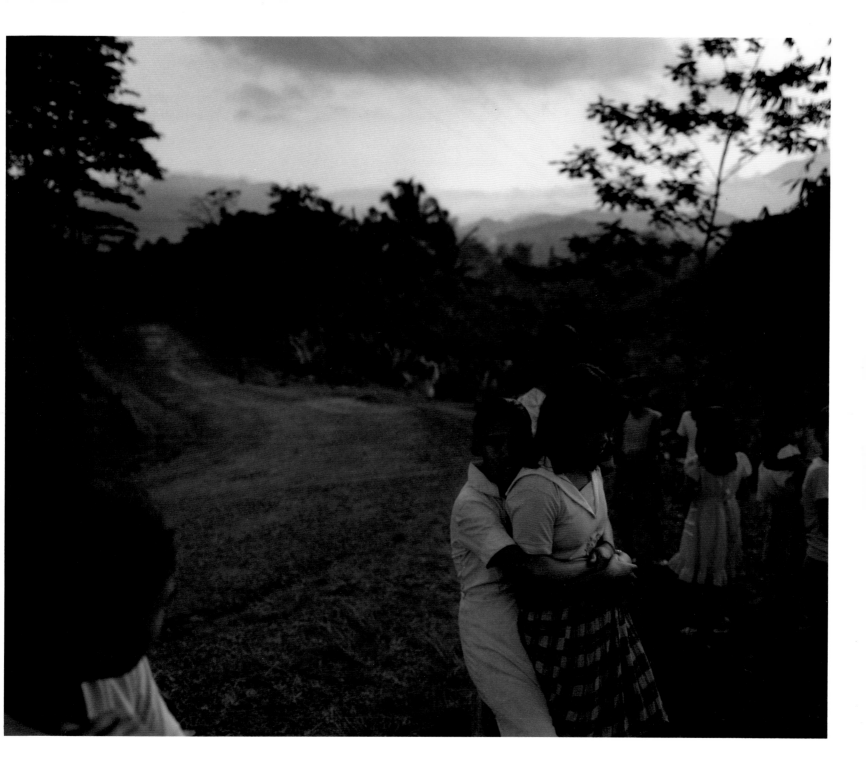

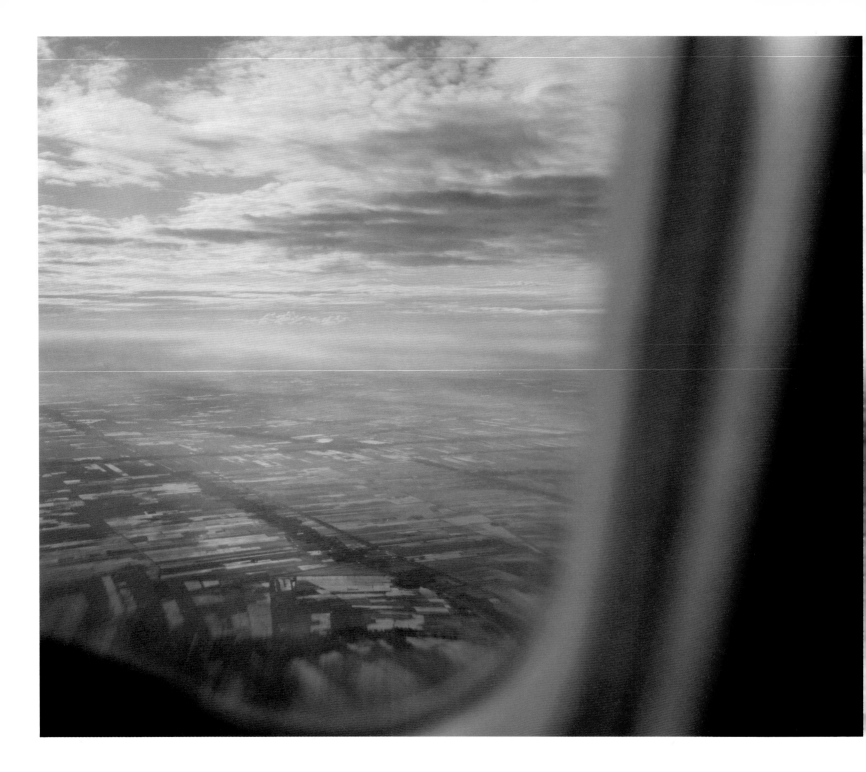

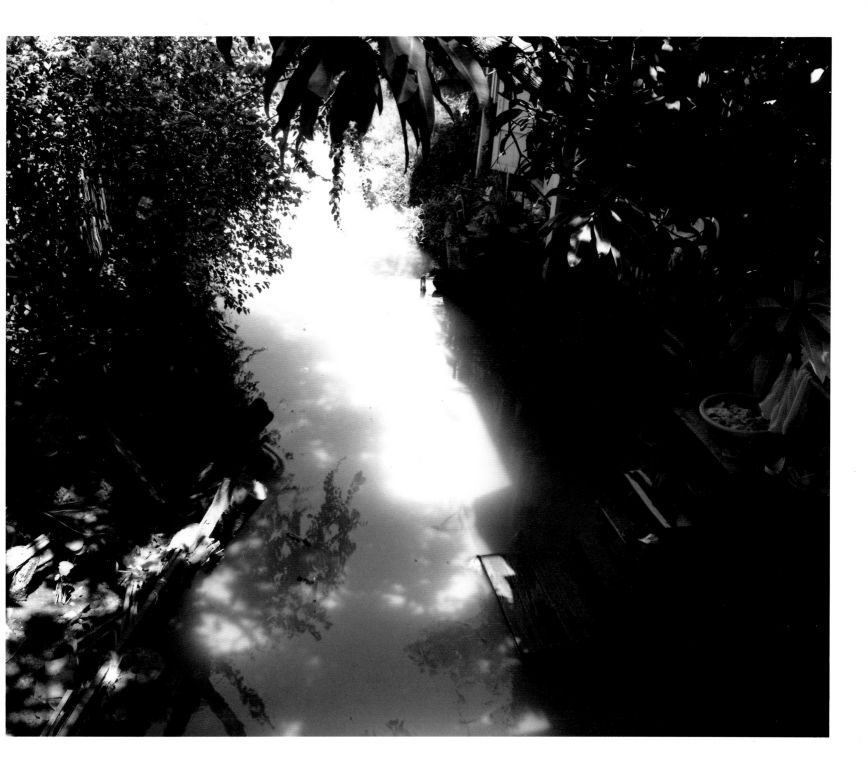

THE PHOTOGRAPHS

PAGE 15 *A MAN IN A WESTERN SUIT,* YASUKUNI BOULEVARD, SHINJUKU, TOKYO, JAPAN, *1986*

16 *AN INDEPENDENCE DAY MURAL IN AN ALLEY,* JAKARTA, INDONESIA, *1987*

17 *THE 'SING SING SING' AND OTHER RESTAURANTS,* SPAIN HILL, SHIBUYA, TOKYO, *1986*

18 *A MAN IN A WESTERN SUIT,* AMEYOKO ALLEY, UENO, TOKYO, *1986*

19 *IN THE ENTRANCE TO A FISH RESTAURANT OFF JORDAN ROAD,* KOWLOON, HONG KONG, *1983*

20 *IN THE SUPER-EXPRESS STATION,* ATAMI, JAPAN, *1984*

21 *AT AKASAKA-MITSUKE CROSSING,* TOKYO, *1984*

22 *A ROOM MAID IN THE URASHIMA HOTEL,* KATSUURA, KII, JAPAN, *1984*

23 *IN A TEMPLE COURTYARD,* BANGKOK, THAILAND, *1985*

24 *APARTMENT BUILDINGS IN THE MIDLEVELS,* HONG KONG, *1987*

25 *CIGARETTE ADVERTISEMENTS IN THE CENTRAL MARKET,* CALCUTTA, INDIA, *1986*

26 *A WOMAN WATCHING A PARADE PASS BY,* YOKOTE, JAPAN, *1984*

27 *AN OFFICE BUILDING,* CHUNGKING, SZECHUAN, CHINA, *1986*

28 *IN THE SUMMER PALACE,* NEAR PEKING, CHINA, *1983*

29 *WEDDING GUESTS IN THE PALACE OF GIANYAR,* BALI, INDONESIA, *1980*

30 *ON A FLIGHT TO PAGAN,* BURMA, *1980*

31 *THE VIEW FROM THE ROOF OF THE YUNGANG HOTEL,* DATONG, CHINA, *1986*

32 *BAR GIRLS IN THE KING'S CASTLE BAR,* PATPONG, BANGKOK, *1984*

33 *IN THE ENTRANCE TO A BAR NEAR CLARK AIR BASE,* ANGELES, THE PHILIPPINES, *1983*

34 *A TOY SELLER,* OFF JORDAN ROAD, HONGKONG, *1984*

35 *A NECKLACE AND EARRING SELLER,* AMEYOKO, TOKYO, *1984*

36 *IN A VIDEO GAME PARLOR,* AMEYOKO, TOKYO, *1984*

37 *LADIES IN A CAFE OFF AOYAMA BOULEVARD,* TOKYO, *1986*

38 *ABOVE A BACK STREET,* SHINJUKU, TOKYO, *1984*

39 *A LYCHEE JUICE BILLBOARD BEHIND THE HOTEL INDONESIA,* THAMRIN ROAD, JAKARTA, *1985*

40 *A PORTRAIT PAINTER'S WINDOW NEAR YOKOSUKA NAVAL BASE,* JAPAN, *1984*

41 *LEAVING MARUYAMA PARK AFTER CHERRY-BLOSSOM VIEWING,* KYOTO, JAPAN, *1986*

42 *AT ARAI-YAKUSHI STATION,* TOKYO, *1983*

43 *AT MEIJI SHRINE ON SEVEN-FIVE-THREE DAY,* TOKYO, *1983*

44 *IN A CHINESE TEMPLE,* BANGKOK, *1987*

45 *GOVERNMENT MEN MAKING NEW YEAR'S CALLS,* TORANOMON, TOKYO, *1988*

46 *A WEDDING COMPANY'S WINDOW,* SHANGHAI, CHINA, *1986*

47 *GIRLS IN THE DUNKIN' DONUTS SHOP,* PATTAYA, THAILAND, *1987*

48 *ON THE CHAO PHAYA EXPRESS BOAT,* BANGKOK, *1986*

49 *ON THE FERRY TO YANAI,* JAPAN, *1980*

50 *IN THE '007' BAR,* ERMITA, MANILA, THE PHILIPPINES, *1986*

PAGE 51 *IN A POOR FAMILY'S HOUSE,* MAKASSAR, CELEBES, INDONESIA, *1983*

52 *IN THE BAR OF THE PEKING HOTEL,* PEKING, *1983*

53 *A VIEW FROM A BRIDGE,* CHUNGKING, *1984*

54 *A POOR FAMILY'S HOUSE,* CHENG-TU, SZECHUAN, CHINA, *1984*

55 *IN THE PARKING LOT AT THE ROPEWAY STATION,* MT. ASO, JAPAN, *1980*

56 *AT SHINOBAZU POND,* UENO, TOKYO, *1980*

57 *NEAR THE BANJIR CANAL,* JAKARTA, *1987*

58 *A TEA HOUSE,* KUNMING, CHINA, *1984*

59 *A WATCH REPAIRER'S,* CHUNGKING, *1984*

60 *AT SOOCHOW CREEK,* SHANGHAI, *1987*

61 *CARD-PLAYERS IN A BACK STREET,* SHANGHAI, *1983*

62 *A BACK ALLEY IN THE OLD TOWN,* SHANGHAI, *1987*

63 *POOR PEOPLE'S HOUSES,* JAKARTA, *1987*

64 *A JUNK DEALER'S WINDOW,* CAUSEWAY BAY, HONG KONG, *1987*

65 *ANOTHER ALLEY,* GOTANDA, TOKYO, *1983*

66 *THE FOYER OF THE DOMOTO MUSEUM,* KYOTO, *1984*

67 *BOYS POSING AS SHAOLIN WARRIORS,* NEAR KAMPUNG SASAK, SURABAYA, INDONESIA, *1983*

68 *IN A DISCOTHEQUE OFF EPIFANIO DE LOS SANTOS BOULEVARD,* MANILA, *1986*

69 *A DEFECATING BOY,* SURABAYA, *1983*

70 *A MAKESHIFT KITCHEN IN AN ALLEY,* SHANGHAI, *1983*

71 *A HOUSE IN A BACK ALLEY,* PEKING, *1986*

72 *ON THE ZAMBOANGA WHARF,* MINDANAO, THE PHILIPPINES, *1983*

73 *THE PACIFIC OCEAN AT KATSUURA,* KII, JAPAN, *1979*

74 *IN A BACK STREET,* BANGKOK, *1986*

75 *ON THE BREAKWATER AT KENCERAN BEACH DURING IDUL FITRI,* SURABAYA, *1982*

76 *IN A BACK STREET,* MANILA, *1986*

77 *IN THE LATE AFTERNOON IN SUMMER,* CHUNGKING, *1986*

78 *ON A SLOW TRAIN TO SURABAYA,* EAST JAVA, *1980*

79 *FROM THE VERANDAH OF THE ORIENTAL HOTEL,* BANGKOK, *1986*

80 *GARBAGE IN THE CHAO PHAYA RIVER,* BANGKOK, *1987*

81 *A STONE LANTERN IN A GARDEN,* BEPPU, JAPAN, *1984*

82 *AMONG THE STILT HOUSES,* KUALAKAPUAS, SOUTH BORNEO, INDONESIA, *1987*

83 *IN AN ALLEY,* JAKARTA, *1987*

84 *A CHERRY-BLOSSOM PICNIC IN A GROVE,* MIYAJIMA, JAPAN, *1984*

85 *IN THE TAISHO EMPEROR'S ROOM AT THE FUTAMIKAN,* FUTAMIGAURA, JAPAN, *1984*

86 *A BUILDING UNDER CONSTRUCTION,* GOTANDA, TOKYO, *1984*

87 *IN A JUNK SHOP,* RANGOON, BURMA, *1983*

88 *A MAN AND CHILDREN ON A BRIDGE,* BANJARMASIN, SOUTH BORNEO, *1987*

89 *A WOMAN AND CHILDREN AT A HAWKER'S CART,* BANDUNG, WEST JAVA, INDONESIA, *1987*

90 *AN ALLEY IN CHIANG MAI,* THAILAND, *1986*

91 *IN THE NORTHWESTERN HILLS,* KYOTO, *1984*

92 *A LABORER,* WONOSOBO, CENTRAL JAVA, *1985*

93 *A PIG PEN, SITE 8 REFUGEE CAMP,* NEAR ARANYAPRATHET, THAILAND, *1987*

94 *TOURISTS AND THE WATER GATE OF ITSUKUSHIMA SHRINE,* MIYAJIMA, *1980*

95 *A RUINED HOUSE NEAR HOT,* THAILAND, *1985*

96 *A DEVASTATED GUN TOWER NEAR QUANG TRI,* VIETNAM, *1984*

97 *A HANDMADE CHAIR, SITE 7 REFUGEE CAMP,* NEAR ARANYAPRATHET, *1985*

98 *A RUINED TANK TURRET NEAR QUANG TRI,* *1984*

99 *HMONG CHILDREN AT BAN NAM YAO REFUGEE CAMP,* NAN PROVINCE, THAILAND, *1983*

100 *GARBAGE IN THE CHAO PHAYA,* BANGKOK, *1987*

101 *A BACKWATER AMONG THE STILT HOUSES,* KUALAKAPUAS, *1987*

102 *CHILDREN INSPECTING FOREIGNERS,* DIENG, CENTRAL JAVA, *1982*

103 *IN A BARBER SHOP,* NORTH SUMATRA, INDONESIA, *1985*

104 *A DECORATED CAR IN THE FLOWER MARKET,* CALCUTTA, *1986*

105 *A CHRYSANTHEMUM GARDEN,* CHENG-TU, *1984*

106 *HANDMADE HOUSES, SITE 2 REFUGEE CAMP,* NEAR ARANYAPRATHET, *1987*

107 *AN ALLEY COURTYARD,* JAKARTA, *1987*

108 *A DITCH AND VINES,* SITE 2, *1985*

109 *A HANDMADE BRIDGE,* SITE 8, *1987*

110 *DANCERS IN THEIR DRESSING ROOM IN AN ALLEY THEATRE,* SUSUNO SUKO, YOGYAKARTA, INDONESIA, *1980*

111 *BOYS IN AN ALLEY,* BANJARMASIN, *1987*

112 *A MURAL IN DOI SUTHEP TEMPLE,* CHIANG MAI, *1984*

113 *AN IDIOT IN A DOORWAY,* PADANG SIDEMPUAN, NORTH SUMATRA, *1985*

114 *PIGS' HEADS AT A STREET MARKET,* CHUNGKING, *1986*

115 *A CAFE TABLE,* BANGKOK, *1987*

116 *A FRENCH HOUSE DAMAGED BY GUNFIRE,* BEN TRE, VIETNAM, *1984*

117 *A FAMILY ALTAR BESIDE A CANAL,* BANGKOK, *1986*

118 *GIRLS WITH A BABY,* SURABAYA, *1983*

119 *GIRLS BESIDE THE GARUT-TASIKMALAYA ROAD,* WEST JAVA, *1982*

120 *LEAVING BANGKOK AT SUNRISE,* *1979*

121 *A CANAL IN THONBURI,* BANGKOK, *1987*

AFTERWORD

by Donald Richie

THIS IS NO ORDINARY MAP. It is not a representation on paper of the earth's surface, abstracted and scaled down. Much has been left out – entire countries – and distinctions, boundary lines, have been obliterated. We do not know where we are, unless we turn to the plate listings at the back of the book, and we do not care. And, as for scaling down, this map seems to have been scaled to size.

If there were a map which resembled this one, it might be Borges': an imaginary representation drawn to a one-to-one scale, completely covering the terrain it delineates. Leo Rubinfien's map does not intend to show how Asia looks – how the place merely *looked*. It wants to define its subject by subsuming it. The photographs do not illustrate a world we already know, but bring into being a poetic one which did not exist before, the photographer's experience of Asia. Yet this continent is in direct correspondence, one-to-one, with that East which is really there, across the water, just opposite the West.

PEOPLELESS INTERIORS, imbued with a humanity so strong you can smell it. We could be in Celebes or in Szechuan. Roses, scotch-taped to a Calcutta sedan or spider chrysanthemums nodding in a Cheng-tu garden. Looking at our feet, walking this Asian soil, we stop at a sump, a quotidian array of refuse. This one is in Bangkok, it turns out, others are in Borneo, but all are waterscapes wider than countries. And behind all these scenes lies a powerful principle. Leo Rubinfien's map is built of palpable, dramatic agreements. Porcine man/porcine fish; shrieking monk sucked down to hell/idiot boy laughing up from hell – these are just the most obvious cases. While many – perhaps most – photographers search out the incongruous, the incompatible, the irreconcilable, and thus make their witty points, this photographer looks for and discovers the congruence, the accord, the consistency.

Geographical particularity, the specifically national, the public scene – all are unimportant. We are on, says the captions list, the flight to Pagan. There we see an Asian face, horn-rimmed glasses, man in an airplane. Leo Rubinfien must also have been on that flight. He made the picture. But there is in this collection no picture of Pagan itself. Perhaps its pagodas were already too famously particular, and the point of the pictures is never anecdotal. Rather, their point is metaphysical. Through the found accord,

the refusal to discover divisions, the photographer seeks to move closer to a truth – that which he has discovered at the juncture of himself and the actuality of Asia.

And he is right to search among the similarities. One of the realities of the region is that it is, even now, spared the assumptions of difference, of conflict, that have lent the West some of its glories (sonata forms) and given it many of its miseries. People in the East still assume that they will get along. The live cat, the plastic Buddha, the real rock – no differences are assumed, they are more alike than not. An Asian thought, which Leo Rubinfien shows.

Let us begin at the beginning, at the surface. This is where the photographer himself begins. "It is only shallow people who do not judge by appearances." This happens to have been penned by Oscar Wilde, but it could have been the maxim of an Asiatic sage. The truth of appearances is the first line to write on the nude map of the East.

The veracity of the facade: posters in Calcutta speak in two dimensions of blood and naked men; the Jakartan mural piles up scrawled dreams of the brilliant future – satellite, skyscrapers, computers, microwave tower, telex machine rolling out "freedom." Things cover things, maps cover maps, as Tokyo's Spain Hill climbs its modest mountain. "Fuck Communism" defines the Clark Air Base, and there are portraits of portraits in Shanghai, and photographs of photographs in Yokosuka. There are views through windows, through doors, and the surfaces turn, spin, reveal. In Tokyo this play joins glass and mirror and the real, all occurring on the Aoyama Boulevard with no telling from which direction anything comes, everything equally real at first sight.

Yet the seeing here is of greater consequence, is more intense, more concentrated, more permanently fixed than our ordinary regard could ever contrive. Leo Rubinfien creates an illusionary picture in which everything appears as natural and unmediated as, say, the world flowing by outside a train window, or that of an airplane, and yet, so pregnant is the image that this photographer continually seeks out that his view seems alive with meaning, with value. The quotidian, the everyday, we know – but his long look makes it felt. For the photographer, the shock of the familiar is identical with the shock of the new. He recoils and we remember.

SEE WHAT HAPPENS when he really does make a picture through a train window: on the slow train to Surabaya, two girls sleep in the heat, a sight common enough in the East as elsewhere. There they lie, still, defined, detailed. But the camera also sees, just outside the window, train passing a village, two boys, blurred but palpable on the embankment, making meaning.

What meaning? – Who are the boys? Which are they of the blurry visitors in the dreams of the dreaming girls? Imaginary brothers? Future husbands? Both or neither of these? Both and neither and yet others still, and so finally the subject is the product of the picture. The photograph does not refer to its subject, it creates it. The intention of the photographer, his very character, pervades. He lies on his landscape – as does Borges' map – and by covering it, reveals it.

These moments must be arranged – as they are here – by affinity rather than by category; their sequence is a story, the map a road. It leads somewhere. Looking from one place to another one must infer, as one does from any map. And you must read and search, even scrutinize, as you would do with any piece of good writing. When you do, themes emerge. Scanning, one may quickly ascertain one of them, right on top. Eastern men in western suits. But are these there because they are there, in the various Asian places, or are they there because they form an artery on this map? And if so, how: western outside but still eastern within? Eastern turning western as we watch? Western suits worn in a manner we cannot but find eastern?

Do not look for an answer. Look, rather, for a commonly shared ambiguity: the congruence of the subject's qualities and the photographer's intentions.

SEEING WHAT IS THUS SHARED, looking deep into this mutuality, we are shown a kind of innocence. A boat at Zamboanga wharf, children making binoculars with their fists, bathing in the long last light of a golden afternoon. In the lambent idyllic light, Surabayan boys pose for the camera in the routines of Shaolin movie heroes, joking, their faces say, at the watching foreigner's expense, but equally knowing that the joke is on them – knowing that we know that they are, after all, not warriors but only

boys. West Javan girls of pure femininity embracing at sunset – that Asian light again, gold turned to rose, and now toward tender darkness as the sun declines.

And the golden age concludes. One walks warily to this idea. After all, the westerner has long made it his business to find the East innocent, and picturesque, and childlike, so that he may, at best, condescend, and at worst, colonize. Asia has long been for the rapacious West the home of an attributed innocence.

And yet, a kind of innocence clearly remains. And the westerner seeks it out because he is envious, wanting, in need. It is as near an absolute value as the westerner owns.

For those who so hanker we have a word. We are romantics. We search for those moments when messy reality reveals that unity that stitches up meaning. And in an East that contains more grace, more accord, more unity than we can ourselves contrive, we believe we have found it.

Such innocence is in the eye of the beholder. The innocent Asian, if he recognized the quality at all, would merely disparage himself as ignorant. But in photography, it is the knowing and feeling eye through which we see. We see what it sees, not what is seen. The subject is transformed by the longing intelligence that addresses it.

THE PHOTOGRAPHER MUST SEE, must understand, must form, frame, clarify. At the same time he must not obscure the life that originally commanded his attention. And here lies the special value of the photograph – in the unshaped and unreconciled reality that flowers within the very structure picture-making imposes.

One most admires those pictures in which the maker has laid form very lightly upon the world. There was once this gaping, ruined house, leaning in the flat red dirt of this land. It is still there – in our minds, where it will always remain, expressing perhaps a will of its own, now that it can no longer be there where it was. Another structure, black, perhaps menacing in a green field by a river: we may think we under-

stand more when we learn that the land is Vietnam, but we have understood all from the first – a tower at once intact as weird fact, and potent as malignant symbol.

There is here, as in most of the photographs, that necessary tension between subject and see-er. The finest photographers are those who embrace this tension – between the desire to shape and find meaning, and the random flow of nature, of reality itself. The result is a fecund ambiguity, reverberant with possibilities. Housefronts in a Jakarta alley, and from the lower right hand corner a boy's hand coming up in an uninterpretable but urgent wave. In the hot garbage of Bangkok a family altar, bashed-up but still showing that love – which we must ourselves salvage – with which someone arranged the awful kitsch dogs on its portico. The goal is a piece of poetry in which the physicality of the photographer combines with the subject to recover that first apprehension of meaning – when he first saw what he *had* to make a picture of – a re-enactment, forever, of that particular and vital moment of his life.

So few lead vital lives. Yet we each have our own personal Asia. And there the most ordinary stuff can appear before us with even visionary intensity, an intensity that can be suspended, given perpetual life, in a piece of good work. Thus may the ordinary become extraordinary, be transformed, rescued, redeemed. Which might be Leo Rubinfien's credo, if he had one. His map of the East leads us in this precise direction, presents us with this inescapable conclusion.

Tokyo, 1991

ACKNOWLEDGEMENTS

THE PHOTOGRAPHS dated 1983 and 1984 were made while I held Fellowships given by the John Simon Guggenheim Memorial Foundation and the Asian Cultural Council. Without the Fellowships those pictures would not be, while a 1992 grant from the Guggenheim Foundation toward this book's printing has helped finish my work in Asia ceremoniously and left me enduringly grateful. At the start, the encouragement of Garry Winogrand, Jeffrey Fraenkel, Lee Friedlander, Marvin Heiferman and Betsy Baker meant a very great deal to me. Donald Richie's encouragement was continuous, and ideas he expressed before I was old enough to understand them are part of the basis of the work.

Many people gave generously to me in Asia, but I thank most of all Rob Burrows in Bangkok, Vu Thanh in Hanoi, Koko Yamagishi and Akiyoshi Taniguchi in Tokyo, and Zhang Changqing in Shanghai.

In New York, Anita Walsh and Judith Mizrahi gave very much as lab assistants, and I am especially indebted to Gail Ludwig, who critically and lovingly made the prints from which the book actually comes. Regina Alvarez attached the success of the project to her own pride, and indulged me in many ways that, fortunately, she can now laugh at. In editing and sequencing the photographs I was lucky to have the advice of Lee Friedlander, Shulamith Rubinfien, Maria Morris Hambourg, Joseph Lawton, Ben Lifson and Lois Conner.

A MAP OF THE EAST might not have reached publication were the photographs not to be exhibited in museums. For her leadership here, and even more for her understanding of the work, my gratitude to Maria Morris Hambourg is immense and will not end.

I also deeply appreciate the support of Rod Slemmons, Graham Howe, Tsuneo Takase and particularly Koko Yamagishi, who has given great effort to bringing Japan an alien's view of Japan–never an easy thing. Richard Lanier, Carole Kismaric and Roger Conover helped further the book's cause; Jamie Camplin and Shigetake Mochizuki helped enable it financially by publishing it in London and Tokyo. Pepe Karmel supported my work from the start, then later made a vital contribution toward the book's printing. Joseph Guglietti put more thought and care into its design than he could ever have been paid for.

At the Toppan Printing Company Minoru Kamigahara, Toru Moriyama, Brad Roth, Koji Miyagi, Makoto Nakagawa, Nobuo Hirasawa and Hiroshi Yoshida devoted themselves to producing the book meticulously. Atsushi Yamamoto, Director of Toppan Process Printing, made it a personal project of his. Just as dedicated, in David Godine's office, were Lucy Hitchcock and Sally MacGillivray.

David Godine has filled me with affection and respect. And while few arts can be more different than photography is from those of the theatre, and although I cannot easily explain how, I think some part of the splendid teaching of Suzanne Shepherd has also made its way in and imprinted itself here.

I want finally to thank Connie Marks, who gave to the project in almost every way, even before it was a project. Its conception was partly hers; I understood its themes talking with her; countless specific ideas in the book's editing and sequencing were hers; she exhorted me to continue when I was discouraged and celebrated the results before anyone else. The book even contains one picture that, in North Thailand, she directed me to make, seeing what its subject might mean before I did. She will appreciate the book as few can; after myself she has more right than anyone to consider it her own.

L.R.

LEO RUBINFIEN first went to live in Japan at the age of nine, accompanying his family there in 1963. He is a graduate of Yale University and has held Guggenheim and Asian Cultural Council Fellowships. His photographs appear in the collections of institutions that include the Museum of Modern Art and the Metropolitan Museum of Art, New York, the San Francisco Museum of Modern Art and the Corcoran Gallery of Art, Washington. One-man exhibitions coinciding with the publication of this book will be given by the Metropolitan Museum of Art in 1992 and the Seibu Art Forum, Yurakucho, Tokyo, in 1993. Mr. Rubinfien has also directed two short fiction films, *The Money Juggler* (1988) and *My Bed in the Leaves* (1990). He lives in Croton-on-Hudson, New York.

DONALD RICHIE was born in Ohio, but has lived largely in Japan since 1946. He is the leading Western authority on Japanese film and the author of numerous books on Japan and its culture, including the acclaimed *The Films of Akira Kurosawa, Different People, Ozu,* and *The Inland Sea.* He was formerly Curator of Film at the Museum of Modern Art, New York. Mr. Richie lives in Tokyo.

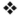

A MAP OF THE EAST was designed by Joseph Guglietti in New York City, in collaboration with the author; the original prints from which the book was produced were made by Gail Ludwig, under the author's direction.

The book was printed in Tokyo by the Toppan Printing Company. The Director of Platemaking was Atsushi Yamamoto, the Scanning Operators were Makoto Nakagawa and Nobuo Hirasawa, and the Printer Hiroshi Yoshida.

The texts were set in the Adobe issue of Berthold Baskerville, and composed on an Apple Macintosh using the Quark XPress program. Baskerville, originally designed by the eminent English printer John Baskerville in 1757, is a fine example of a traditional typeface. Berthold Baskerville was chosen for its faithful attention to the proportional characteristics of the original version, which makes it pleasant and extremely readable.

The titles and page headings were set in an expanded version of Frutiger, which was designed by Adrian Frutiger in 1975 for signage in the Charles de Gaulle Airport, Paris. Though Frutiger's primary goal was legibility he also sought to create a sans serif type less rigid than the most popular sans serif faces available at the time, Helvetica, and Univers, which he had designed two decades before. Pleased with the new face, he named it after himself.